the 7 essentials of graphic design

the 7 essentials of graphic design

allison
GOODMAN

HOW
DESIGN
BOOKS

Cincinnati, Ohio
www.howdesign.com

[copyright]

Visit our Web site at www.howdesign.com for more resources for graphic designers.

07 06 05 04 03 8 7 6 5 4

U.S. Library of Congress has catalogued this book as:
Goodman, Allison
 The 7 essentials of graphic design / Allison Goodman.
 p. cm.
 Includes index.
 ISBN: 1-58180-124-6 (pb w/flaps)
 1. Graphic design (Typography). I. Title.

Z246 .G64 2002
686.2'2--dc21 2001024741

➣ EDITED BY KIM AGRICOLA, LINDA HWANG & CLARE WARMKE
➣ COVER DESIGN BY ANDREA SHORT
➣ INTERIOR DESIGN BY ANDREA SHORT
➣ INTERIOR PRODUCTION BY KATHY GARDNER
➣ PRODUCTION COORDINATED BY KRISTEN HELLER

dedication

This book is dedicated to three wonderful women.

First, to the loving memory of my grandmothers:

Ruth Blum, for a lifetime of friendship,

intelligence and inspiring grace.

Telsa Goodman, who advocated her independent

ideals, in part, by underwriting my college education.

And finally, to the passion and commitment of

my undergraduate professor, Karen Moyer.

acknowledgments

Because of the instrumental role that teaching has played in the creation of this book, my first thanks is to my many students and to my teachers, both of whom have over the years shared their inspired thoughts on design. To Ramone Muñoz, Andy Davidson and Ron Jones, I offer my appreciation for inviting me to teach at Art Center and for continually supporting my role at the school.

I would also like to thank my colleague Petrula Vrontikis who suggested that I look into writing this book; Lynn Haller, Linda Hwang, Clare Warmke and Kim Agricola of HOW Design Books for their expert guidance; and the many design studios who graciously contributed work for publication in *7 Essentials*. And finally, I offer my deepest gratitude—for everything—to my husband Daniel and our two children.

[thank you]

table of
CONTENTS

ch.01

ch.02

ch.03

intro-
DUCTION

["The fact is that we live

in a designed world

and we will never

live in any other kind."]

ralph
CAPLAN
By Design

Introduction

In the twenty years that I have practiced and/or taught, my fascination with graphic design has never faltered. The profession has continually challenged both my left *and* right "brains," exercising my passion for the quantifiable and my zeal for creativity. It has also offered many chances to consider the implications of my actions on the world at large. Because of the research and experiences I have had each time I entered a client's world, I've explored ideas about jazz and classical music, women's rights, baseball, bigotry, catering and world travel—just to mention a few—having a chance to learn about more topics than I could have otherwise imagined. Teaching has only added to that reservoir of experiences. Students are a constant source of new ideas, as they bring their thoughts about culture as well as design to the classroom experience.

Becoming a graphic designer is a matter of interest, training, experience and perhaps most of all *thinking* about the world around you and how you plan to communicate with its inhabitants. When students ask what magazines they should read to stay on top of the world of design, I answer, "The daily paper of your choice and *The New Yorker* magazine." Of course they are expecting me to recommend actual design magazines. While *The New Yorker* is a subjective choice, reading the newspaper is a requirement, because to fail to understand the world around you is to never quite ascend to the role of communicator. That said, books on graphic design and other publications regarding the arts are great ways to add to your reservoir of ideas and inspirations. (Go ahead and imitate your favorite designer...by the time you suffer through that exercise, you will have learned enough to do it your own way!)

My intention is that *The 7 Essentials of Graphic Design* will be a worthwhile addition to your design library. The book's approach, which explains design through the juxtaposition of basic ideas with sophisticated and sometimes complex work, is a strategy that illustrates the idea that the essentials are always at the foundation of interesting and successful designs. The writing itself is a reflection and distillation of what I have learned both as a professional and as a design instructor. It has been an interesting task to formalize my many different design thoughts into writing, as typically they have taken verbal form through presentations, lectures, critiques and informal discussions. I hope that your interest in graphic design is strengthened by this book and that your professional experiences offer you the chance to grow, both as an individual and as a designer.

re-
SEARCH

Each client has a story to tell. Your job as a designer is to express the true essence of

a client's business or organization—which is impossible to do without research. Learn

to uncover a client's story, and your design process will be more informed and your

goals more defined from the start!

.01

CHAPTER

["Ideas may grow out of the

problem itself, which

in turn becomes part of the solution."]

p a u l RAND
A Designer's Art

["A designer needs to take account

of the nature and needs

of the people who are to use the design."]

m a l c o l m GREAR
Inside/Outside

What Story Does the Client Want to Tell?

Before the visual aspects of design process begin there is the research phase. Research is an opportunity to immerse yourself in the "culture" of the project you are about to concentrate on. It's a chance to broaden your horizons with experiences that will make the project, and even the life you lead outside of design, more interesting.

While the general perception of this phase may not be glamorous, it is essential to a successful design experience. Thorough research will help a designer: [1] nourish his or her imagination with new information, and [2] provide an opportunity for the designer and the client to agree on the goals of the project.

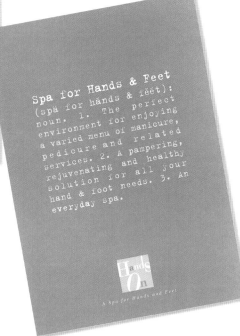

IT IS IMPORTANT

to understand, as appropriate, all aspects of a client's business, from the customer profile to the "tools of the trade." In this spa identity, the color palette is drawn from the items associated with restorative treatments... water, clay, seaweed and other natural materials. The casual but clean Hands On identity reflects how the client feels customers should perceive this mid-priced day spa, something the designer could only find out by asking the right questions early in the design process.

➤ DESIGN FIRM:
VRONTIKIS DESIGN OFFICE
➤ CREATIVE DIRECTOR:
PETRULA VRONTIKIS
➤ DESIGNER:
PEGGY WOO

Research Strategies

Different research strategies can be used alone or in combination to help both the designer and client with identifying the foundation of a successful design:

[1] QUESTION & ANSWER: This involves asking clients the same questions you may have learned in a high school journalism class: Who? What? When? Where? Why? How? If conducting research for a "fancy boutique" project, a brief interpretation of the answers may reveal that the graphics for the store should address females thirty-five to sixty years of age who are buying gifts for family and friends and who don't worry about cost nearly as much as they desire service, originality and prestige.

[2] FIND EXISTING EXAMPLES: Using the upscale boutique example again, if you have already found out that the client perceives his or her project as "very Beverly Hills," then you might do some field research and visit the most upscale part of your city to gather examples of how similar shops present themselves graphically. Business cards, shopping bags, snapshots of storefronts, etc., are all useful research items. No doubt, you will begin to see a trend in the types of graphics that are appropriate to a particular type of retail establishment. Organizing, categorizing and presenting this research to the client can be the foundation of a very successful research phase. Additional research for existing examples of graphic design can be found in publications that cater to the same portion of the public that your client perceives as his or her

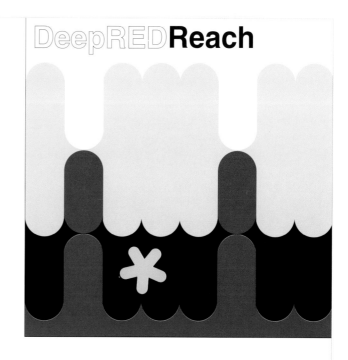

IT'S POP QUIZ TIME! *This CD was designed with which demographic in mind: A) June Alvarado, or B) Nat, Tick and Scrap? Read the section "Create a Typical Scenario" on page 15 if you aren't sure.*

➤ DESIGN FIRM: SEMILIQUID
➤ DESIGNER: MIKE LOHR

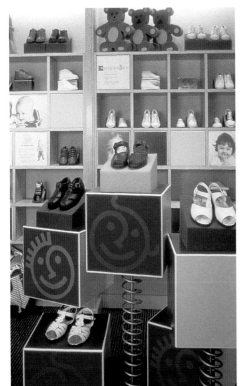

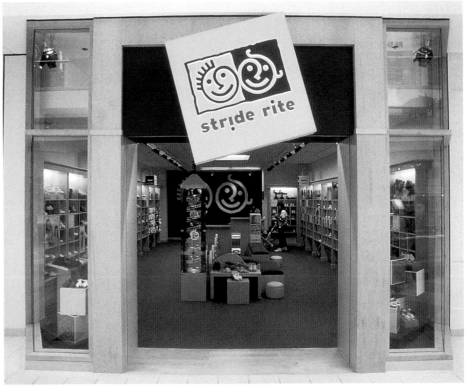

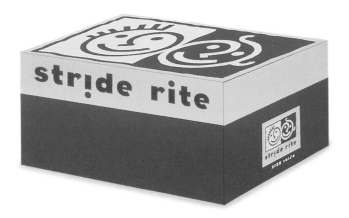

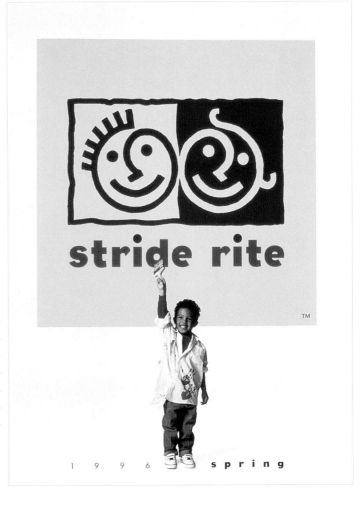

MARKET RESEARCH DEFINED *Stride Rite's target market as well-educated, socially minded young mothers who sought value and selection but found the store difficult to navigate. In response to these facts, the redesign of the retail identity utilized hand-drawn faces as well as clean and sturdy (but fun) type as part of the visual brand strategy developed around the idea: "The joy of growing up." The visual strength of both the logo and logotype allow it to be reconfigured as necessary to address a variety of applications—from print to architectural, small to oversized. In these examples the basic identity is carefully adapted for use on the display cubes, signage and packaging.*

➤ DESIGN FIRM: SELBERT PERKINS DESIGN
➤ CREATIVE DIRECTORS: ROBIN PERKINS, CLIFFORD SELBERT
➤ DESIGNERS: ROBIN PERKINS, JULIA DAGGETT, MICHELE PHELAN, KAMREN COLSON, KIM REESE, JOHN LUTZ

target market. For the fancy boutique, upscale magazines such as *Vanity Fair* and *Mirabella* will provide examples of logotypes and overall graphic style that can substitute for and/or augment field research.

[3] CREATE A TYPICAL SCENARIO:

This process can be helpful when clients are not clear about the ultimate audience for the designs or when you are having some trouble understanding exactly what clients are hinting at with their answers to your questions. The creation of a scenario involves writing a hypothetical story about an imaginary ideal customer. The fancy boutique scenario may start like this: "June Alvarado is a wealthy Chicago socialite. She is fifty-five years old, married to a successful plastic surgeon and the mother of three grown daughters. June is helping her oldest daughter plan her wedding, and there will be gifts to buy for the large contingent of bridesmaids. June is concerned that the gifts be original and appropriate to each individual...." On the other hand, a scenario for a snowboarding ad would feel quite different: "Tick and his high school buddies Nat and Scrap have each just received some Christmas money (about fifty dollars) and are trying to agree on how to make the most of their cash windfall in what remains of the winter vacation...."

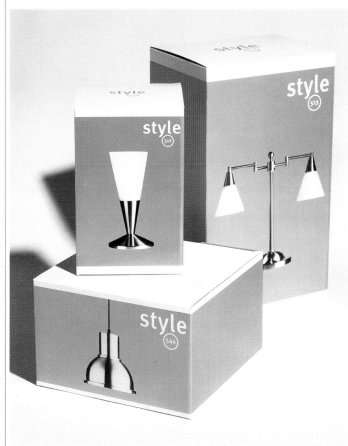

In each case the completed scenario will touch upon customer profile and motivation, price-points, desired outcome and even project scope information that can help the designer and the client understand what the goals of the graphic designs should be. You can write a scenario by either reviewing the research and writing a draft for client input or by asking clients to describe their "dream" customer and then writing a draft for review. Both approaches can help obtain the client's approval on a basic direction for the project—a wise and necessary aspect of any design project.

How Can Research Help Budget a Project?

Even a small bit of research can assist with project budgeting, both for the design fee and the implementation costs.

[1] **Design Fees:** There are several strategies to help understand the scope of a project and its associated design fee.

▶▶▶**LISTS:** One strategy to estimate an appropriate and profitable design fee is to analyze the scope of the entire project, and list everything you think each phase (contract, research, ideation, design development, travel, administration, finalization of design and production, etc.) of the project will encompass. Then estimate how many hours you think each step will take. Add up the hours, *double them* (no kidding, everyone estimates too low), then multiply by the desired hourly income to reach a design fee. Oftentimes it helps to just "guesstimate" the approximate design fee before you begin the previous process just to see if the two numbers are even close. If they aren't, go with the higher of the two numbers.

▶▶▶**ASK:** Another way to assess an appropriate design fee is to ask someone with more experience. This can be another designer; a book, such as the *American Institute for Graphic Artists* pricing guidelines book (although many people feel their monetary standards are unrealistically high); or even a friend/business acquaintance (but not your actual client) who has hired designers in the past.

However you determine your fee, it is important to price the contract in phases, load the fees at the start of the contract and be paid incrementally throughout the project. Incremental payments help insure that you won't get to the end and then find out that the client may not be planning to pay your fees. By making the earlier payments larger than the later payments, you acknowledge the importance of your creative contributions as well as create a hedge against the client taking your concepts to someone "cheaper" for completion/production (sadly, these things do happen in the real world).

[2] **Production Budgets:** It is advisable to present an estimated production budget to your client as part of the research phase (if only to help insure that your design efforts will be able to be implemented by the client—why design a sixteen-page brochure when the client can only afford to print an eight-page version?). Asking printers and other suppliers to share their expertise with you as you research production costs is an excellent strategy. They know that time spent helping budget hypothetical projects and suggesting different production options to help stretch a budget will only increase their chances of being the supplier who is eventually chosen to implement the project.

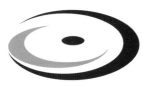

SOUNDFUTURE

SOUNDFUTURE

216 NORTH LUCERNE BOULEVARD TEL (323) 462.1676
LOS ANGELES, CALIFORNIA 90004 FAX (323) 462.1677

www.soundfuture.com

THE SOUND FUTURE identity is a wild mix of references. The typographic treatment is at once contemporary, and a bit "digital-retro." The logo resembles a CD, but also a whirlpool or a galactic phenomenon. One would have to assume, just by looking at this identity, that the client wanted to communicate an experimental, wide-open attitude for their record label.

➤ DESIGN FIRM: GIG DESIGN
➤ DESIGN: LARIMIE GARCIA FOR GIG DESIGN

JERIMAYA GRABHER >> JERIMAYA@SOUNDFUTURE.COM

SOUNDFUTURE

216 NORTH LUCERNE BOULEVARD TEL (323) 462.1676
LOS ANGELES, CALIFORNIA 90004 FAX (323) 462.1677
 CELL (310) 344.9076

www.soundfuture.com

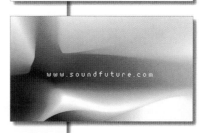

www.soundfuture.com

SOUNDFUTURE

216 NORTH LUCERNE BOULEVARD
LOS ANGELES, CALIFORNIA 90004

www.soundfuture.com

17

TYPE AND LINES *weave past one another on this CD packaging to cre-*
ate an intriguing visual rhythm. The vertical rules bring to mind the frets of a guitar and
their irregular spacing provides an interesting musical tempo. The vertical simplicity of the
typeface fits well with formal qualities of the layout, including the "fret lines" and the ver-
tical row of rectangles that runs behind the title type. The rich sophistication of the project
was not at all hindered by the limitations of a two-color printing budget: The yellow and
black were well utilized through techniques including overprinted and reversed-out type, as
well as the use of duotones in the photographs. This sophistication also could never have
been expressed so well if Anne Burdick hadn't taken the research time to know her client.

➤ DESIGN: ANNE BURDICK: THE OFFICES OF ANNE BURDICK

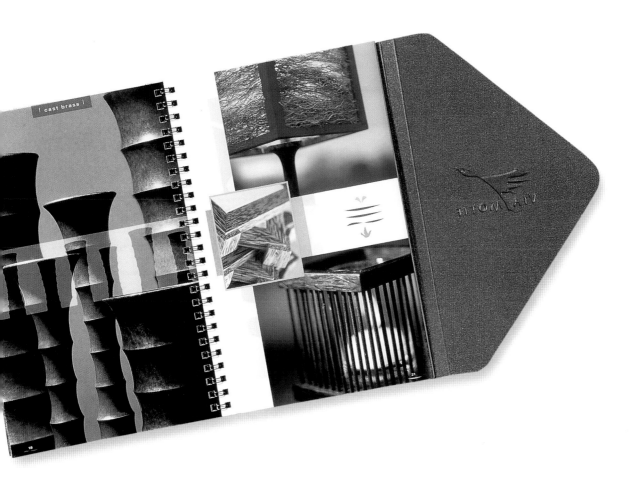

VIA MOTIF

THE DESIGN ATTITUDE *for Via Motif conveys the Indonesian origins of the company through forms developed for the identity, the background patterns of the Web site and the color selection throughout the design program. The Via Motif print catalog features both "ambient" and informational layouts. The contrast between the rich, dense imagery and the clean, organized feel of the foldouts helps illustrate the point of the two different approaches to displaying the products—one is for visualizing the potential of the merchandise, the other is for ordering it.*

➤ DESIGN FIRM: VRONTIKIS DESIGN OFFICE
➤ CREATIVE DIRECTOR: PETRULA VRONTIKIS
➤ DESIGNERS: ANIA BORYSIEWIEZ, PETRULA VRONTIKIS

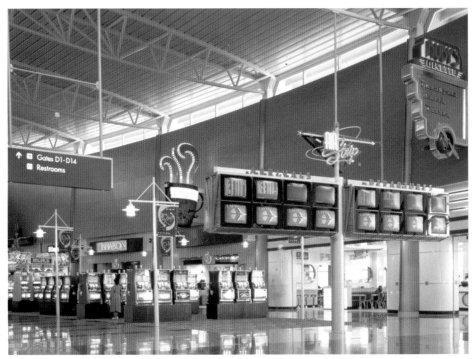

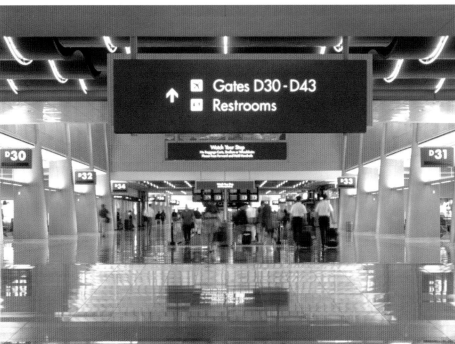

THE IMPORTANCE OF *extremely clear, consistently presented information cannot be over-emphasized when it comes to travel signage. In this category of environmental graphics, extensive way-finding research is conducted to insure that appropriate content and message repetition are achieved. In these signs for Las Vegas's McCarran Airport, the straightforward but stylish system for presenting navigation specifics is complemented by the less formal map imagery in the floor design and neon signage for the airport's leisure offerings, which only travelers not rushing to catch an airplane would have time to appreciate.*

➤ DESIGN FIRM: HUNT DESIGN ASSOCIATES
➤ DESIGNERS: JOHN TEMPLE, DINNIS LEE, STEVE HERNANDEZ

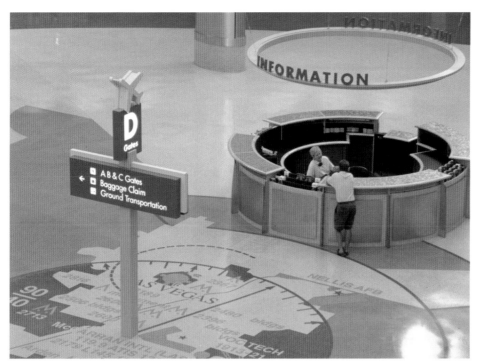

typo-GRAPHY

Typography could be considered a hidden art. But just because the consumer may not

notice your clever creation of a ligature or or your subtle shifting of text alignment

doesn't mean that your efforts aren't crucial to the message. With these type basics,

you can communicate anything.

CHAPTER .02

Discover Your Creativity
With Graphic Design Books!

Sit! Stay! Be creative! It's tough to be creative on command. But with deadlines looming, you can't always wait for inspiration to strike. Sometimes you have to go out and find it.

That's where *Idea Index* comes in. Inside you'll discover thousands of ideas for graphic effects and type treatments, via hundreds of prompts designed to stimulate, quicken and expand your creative thinking.

Use *Idea Index* to brainstorm ideas, to unclog your mind, to explore different looks and approaches in your work, or to stir up some instant creative genius when you need it most!

1-58180-046-0, vinyl paperback, 312 pages

Like it or not, your success in graphic design is determined as much by your work as by how well you promote it. Thankfully, online promotion has opened up a whole new channel for you to generate opportunities for both you and your firm.

In *Self-Promotion Online*, Ilise Benun shows you how boost your bottom line by developing a Web site and an online marketing plan that will increase your exposure worldwide and provide both current and prospective clients with "anytime access" to you and your work.

Plug in and extend your marketing efforts with the power of the latest technology!

1-58180-069-X, paperback w/ flaps, 128 pages

Oddball projects. You know the ones—they tend to sneak up on you when you least expect it. They're also some of the most interesting, challenging jobs you'll tackle.

Creative Solutions for Unusual Projects ensures that you've got the tools and resources you need to handle every such assignment with confidence and skill. Whatever the job may be—from menu design to video packaging to billboards and trade-show booths— you'll find formats, guidelines, quick fixes and gritty solutions. Plus, you'll find insider advice for working with printers, photographers and illustrators.

1-58180-120-3, paperback w/ flaps, 192 pages

Razorfish
Thomas Mueller
32 Mercer St.
New York, NY 10013

RBMM
Shayne Washburn
7007 Twin Hills, Ste. 200
Dallas, TX 75231

Real Design
Jürgen Riehle
30 E. 29th St., 4th fl.
New York, NY 10003

Recording Industry
Association of America
Neal Ashby
1330 Connecticut Ave. NW, #300
Washington, DC 20036

Selbert Perkins Design
Robin Perkins
1916 Main St.
Santa Monica, CA 90405

Semiliquid
Mike Lohr
1326 Edgecliffe Dr., #6
Los Angeles, CA 90026

Stoltze Design
John Nikolai
49 Melcher Street
Boston, MA 02210

Squires & Company
Paul Black
2913 Canton
Dallas, TX 75214

Tom Fowler, Inc.
Thomas G. Fowler
111 Westport Ave.
Norwalk, CT 06851

Visual Dialogue
Fritz Klaetke
4 Concord Square
Boston, MA 02118

Vrontikis Design Office
Petrula Vrontikis
2021 Pontius Ave.
Los Angeles, CA 90025
VSA Partners, Inc.
Steve Arbaugh
1347 South State Street
Chicago, IL 60605

Wages Design
Diane Kim
887 West Marietta St., Studio S-111
Atlanta, GA 30318

Yale University Press
Sonia Scanlon
P.O. Box 902040
New Haven, CT 06520

Young & Laramore Advertising
Paul J. Knapp
310 E. Vermont Street
Indianapolis, IN 46204

[Directory of Design Firms]

April Greiman
620 Moulton Ave., #211
Los Angeles, CA 90031

Art Center College of Design
Allison Goodman, Ellie Eisner
1700 Lida St.
Pasadena, CA 91103

BBK Studio
Yang Kim
5242 Plainfield Ave. NE
Grand Rapids, MI 49525

Beth Singer Design
D. Troutman
1910 1/2 17th St. NW
Washington, DC 20009

**Concrete Design
Communications Inc.**
Diti Katona
2 Silver Ave.
Toronto, Ontario
Canada M6R 3A2

David Carson Design
David Carson
27 West 20th St., Ste. 501
New York, NY 10011

Design Guys
Steven Sikora
119 North 4th St., Ste. 400
Minneapolis, MN 55401

EmDash
Frank Kofsuske
2044 Union St.
San Francisco, CA 94123

Eric Graybill Design
Eric Graybill
1335 Colorado Blvd. #1
Los Angeles, CA 90041

Gig Design
Larimie Garcia
P.O. Box 1431
Oakdale, CA 95361

Global Doghouse, Inc.
Stephen S. Perani
3000 W. Olympic Blvd., Building 5,
Ste. 2160
Santa Monica, CA 90404

Hunt Design Associates
Wayne Hunt
25 N. Mentor Ave.
Pasadena, CA 91106

Kate Rivinus
1633 S. Bundy Dr., #8
Los Angeles, CA 90025

Kim Baer Design Associates
Kim Baer
807 Navy Street
Santa Monica, CA 90405

Lausten & Cossutta Design
Renée Cossutta
1724 Redcliffe St.
Los Angeles, CA 90026

Louey/Rubino Design Group Inc.
Robert Louey
2525 Main Street, Ste. 204
Santa Monica, CA 90405

Mauk Design
Mitchell Mauk
39 Stillman St.
San Francisco, CA 94107

Maurice Berger
740 West End Ave., Apt. 22
New York, NY 10025

Meryl Pollen Design
Meryl Pollen
2525 Michigan Ave., G3
Santa Monica, CA 90404

**Minneapolis College of Art
and Design**
Anastasia Faunce
2501 Stevens Avenue South
Minneapolis, MN 55404

The Offices of Anne Burdick
Anne Burdick
3203 Glendale Blvd.
Los Angeles, CA 90039

frank gehry

[I n d e x]

p.41 (TOP) © Maverick Recording Co./Design: Larimie Garcia for Gig Design; (BOTTOM) © Sheryl Crow "Riverwide"/Design: Larimie Garcia for Gig Design

p.44 © Los Angeles Metro Rail Signage Program/Design: Hunt Design Associates; Designers: John Temple, Jennifer Bressler, Wayne Hunt

p.45 © Gig Design; Design: Larimie Garcia for Gig Design

p.46 © Gig Design/Innovation Snowboards; Design: Larimie Garcia and Edoardo Chavarín for Gig Design

p.47 © Concrete Design/Diti Katona, John Pylypczak, Concrete Design Communications Inc.

p.48 © April Greiman/Greimanski Labs

p.49 © Design: Design Guys, Inc.; Creative Director: Steve Sikora; Designer: Amy Kirkpatrick

p.51 © Design: Kim Baer Design Associates, Los Angeles

p.52 © Global-Dining, Inc./Design: Vrontikis Design Office; Creative Director: Petrula Vrontikis; Designer: Petrula Vrontikis

p.53 © 2000 by Paramount Classics™, a division of Paramount Pictures™. All rights reserved./Design: Global Doghouse, Inc.

p.56–57 © Visual Dialogue; Design: Fritz Klaetke (and Ian Varassi on 2000); Design Firm: Visual Dialogue

p.58 © 1999 Universal Studios/Design: Global Doghouse, Inc.

p.59 © Louey/Rubino Design Group Inc.; Designers: Robert Louey, Alex Chao

p.60 © Recording Industry Association of America/Creative Director, Designer: Neal Ashby; Firm: RIAA

p.61 © Recording Industry Association of America/Creative Director, Designer: Neal Ashby; Firm: RIAA

p.62 © Design: Kim Baer Design Associates, Los Angeles

p.63 © 1999 Museum Associates, Los Angeles County Museum of Art and the Fellows of Contemporary Art/Design: Lausten & Cossutta Design

p.64 (TOP) © Mauk Design; Art Director: Mitchell Mauk; Designer: Mitchell Mauk; Writers: Mitchell Mauk, Damien Martin, Raymond Burnham Jr.; (BOTTOM) © Eric Graybill

p.65 © 1999 Red Gold, Inc./Design: Young + Laramore Advertising; Executive Creative Director: Jeff Laramore; Art Director: Pam Kelliher; Photographer: Tod Martens; Digital Illustration: Jeff Durham; Writer: Scott Montgomery

p.66 © Maurice Berger & The Alliance for Young Artists & Writers/Ralph Appelbaum Associates Incorporated, Author: Maurice Berger, Design: Matteo Federico Bologna

p.67 © Steelcase, Inc./Design: BBK Studio, Inc.

p.68 © Eric Graybill

p.69 © Antec brochures/Design: Wages Design; Art Director: Bob Wages; Designer: Matt Taylor

p.70 © Maverick Recording Co./Design: Larimie Garcia for Gig Design

[Copyright Notices]

react

right

left

THIS CAPABILITIES BROCHURE *is a great example of performing a message through design. The recurring theme of right and left brains is demonstrated through the lists that define the characteristics associated with each side of the brain. Colorful vs. black-and-white treatment of the type further accentuates the differences. To further the theme of brain function, the right-brain pages are on the left, and vice versa. This switch adds to the performance of the message by acting out the crisscross function of brain reception. The simple typographic treatment throughout the brochure is emphasized through its large, tabloid-sized format.*

➤ DESIGN FIRM: LOUEY/RUBINO DESIGN GROUP INC.
➤ DESIGNERS: ROBERT LOUEY, ASHLEIGH MOSES

analyze

create

focus

vision

logic L R passion

intellect

emotion

plan

react

A Closing Argument
for the Basics

In his essay "Craft and Art," the designer Paul Rand wrote the following:

▶▶▶Just as there is no art without craft and no craft without rules, so too there is no art without fantasy, without ideas. It is the fusion of the two that makes the difference.

Whether a design is created on a computer or with cut-paper and paste, it is a knowledge of basic design principles that fuels successful designs. Explaining these principles or "rules" and pointing out how they permeate all types of design has been the focus of this book. Learning the essentials of design and deciding how they will influence and direct your own work is one of the joys of studying and practicing graphic design.

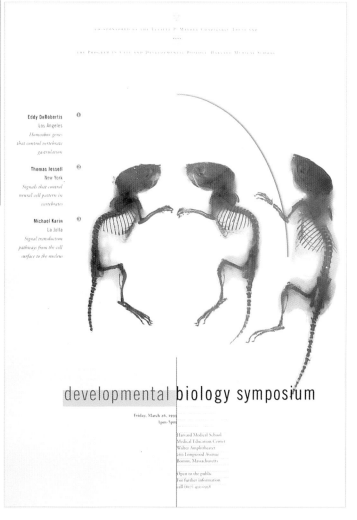

THE DESIGN FIRM Visual Dialogue has managed to bring a certain beauty to genetically altered rats in this poster for a biology symposium. Outside of the strange appeal of the rodent images, much of the poster's success can be attributed to the skilled use of a central axis as a dominant structural element within the design. It is the structure around which most of the elements rotate. Type is either centered over or flush to the axis. Even the two identical rats are mirrored on either side of this implied grid line. The list of speakers, the only type that is not flush to the axis, is actually positioned to diagonally counterpoint the third rat in the image—according to the axis.

➤ DESIGN FIRM: VISUAL DIALOGUE
➤ DESIGN: FRITZ KLAETKE

>>>

THE APOSTLE POSTER *is a simple yet astonishingly effective piece of design. Through a limited palette of elements and efficient display of contrasts, the designers of this movie poster have created a very strong visual statement. While all the headline type runs across the entire width of the poster, the different values and positioning of the type both in front of and behind the figure create a dynamic sense of depth. Likewise, the warm tones of the sky and the cool tones of the figure provide a dynamic color contrast. Finally, the stormy gestures of both the sky and the figure contrast with the straight-edged and simple typeface. Together, these design decisions create an excitement and tension that is almost palpable.*

> DESIGN FIRM: GLOBAL DOGHOUSE, INC.

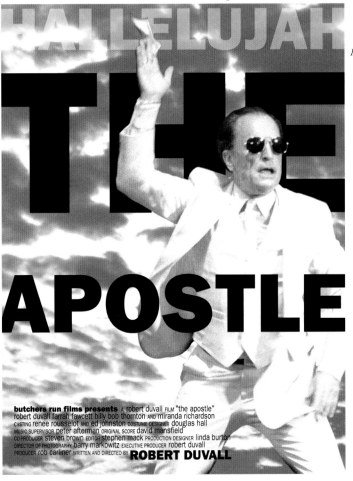

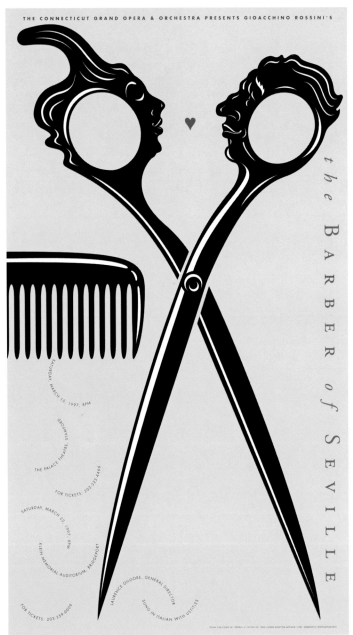

<<<

THIS POSTER FEATURES *clever relationships between the illustrative and typographic elements. The visual and emotional tension between the faces in the handles of the scissors is heightened by the small red heart, and the performance information in the form of hair snippets provides a whimsical and rhythmic element. Successful layout dynamics are also apparent in the relationship between the diagonal scissor forms and the straight elements in the composition (the comb and the title type). Collectively, the design decisions help communicate that there's a fun side to attending the opera.*

> DESIGN FIRM: TOM FOWLER, INC.
> DESIGN AND ILLUSTRATION: THOMAS G. FOWLER

DAVID CARSON, ONE of the pioneers of late twentieth century typographic innovation, creates the tension that his work is known for, as well as a certain restraint in this poster announcing a presentation to the Art Director's Club of Tulsa. The subject of travel has often cultivated critical notions of displacement, and Carson's use of the "seam" in the middle of the poster brings to mind the lost space and time between departure and arrival. The cropped airplane image mimics the cropped title type, and almost all the poster's elements are seemingly headed off the right side of the composition. There is a sense that the poster itself, perhaps like design, is always headed somewhere.

➤ DESIGN: DAVID CARSON

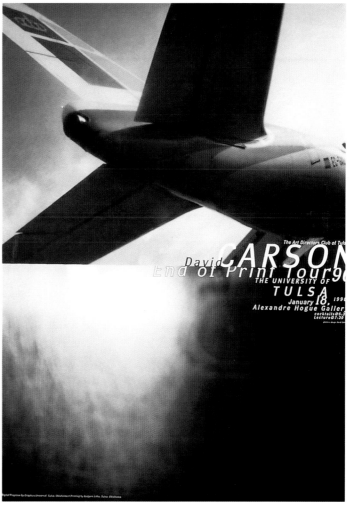

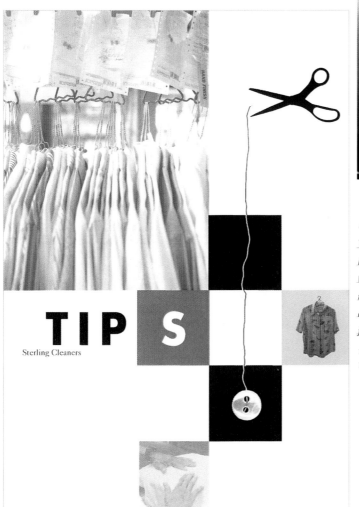

THE SPONTANEOUS BEAUTY of this promotional piece belies the rigid square structure into which most of the design elements have been placed. While it does make sense for a dry cleaner's collateral to feel "clean" and well organized, the use of high and low chroma colors, light and dark values, as well as a light-hearted use of scale (those scissors could really do a number on that shirt!) also add a crucial sense of fun to an otherwise dry subject.

➤ DESIGN FIRM: MERYL POLLEN DESIGN

➤ DESIGN: MERYL POLLEN

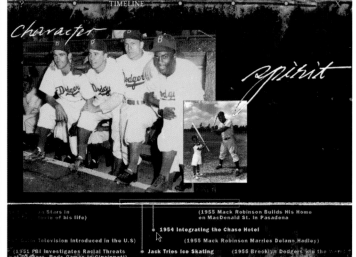

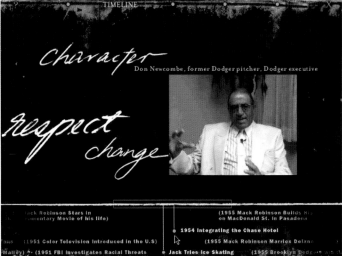

THESE SCREEN SHOTS *from a CD-ROM about the personalities of the famous baseball player Jackie Robinson and his Olympic-champion brother Mack use two types of typography as the primary navigation device. The calligraphic words are character traits. Their hand-drawn representation takes advantage of the subjective association that one makes with handwriting. The navigation device, the dates, are objectively represented through typography. Both take advantage of the appropriate typographic personality. Users can employ either the words, dates or timeline at the bottom of the screen to serendipitously navigate among numerous video interviews. Those with less time and/or a less adventurous spirit can go to the index section to systematically review video clips and read interview transcripts.*

> DESIGN FIRM: ART CENTER COLLEGE OF DESIGN
> DESIGN: BECKY BROWN, ANDREW DAVIDSON, MICHAEL DELAHAUT,
ALLISON GOODMAN, JOEL HANLIN, DEBRA HIDAYAT, EENA KIM,
RUDY MANNING, RION J. NAKAYA, CAROLINE NYANJUI, R. PAUL SEYMOUR,
LAURA SILVA, GINO WOO

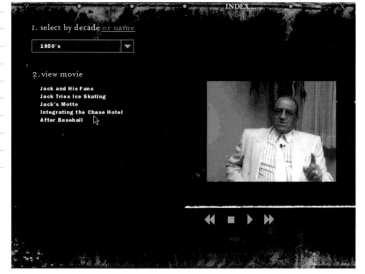

WHEN IT COMES to contemporary design, such as this music industry poster, it's easy to say that the work's appeal resides solely in its hipness. But attitude is often only part of the story, because here, basic design principles are also at work. For instance, the mass of the solid title type contrasts the lightness of the outlined title type. Also, the typographic repetition and layering create beautiful rhythm and depth across the whole poster. Finally, notice how the white support type is flush left to the stroke of the n. This structured approach to the subordinate element provides a nice contrast to the organic flow of the dominant type. The vertical line created along the left side of the support type mimics the vertical lines that "chop off" parts of the title type, creating a successful dialogue between all the poster's elements.

➤ DESIGN FIRM: SEMILIQUID
➤ DESIGNER: MIKE LOHR

$$[\,\omega\alpha s f(a)^2\,]$$

THIS IDENTITY FOR a nonprofit student financial aid service intelligently combines letterforms with mathematical symbols and syntax. The result is a message that acknowledges the financial realities of pursuing a higher education.

➤ DESIGN FIRM: GIG DESIGN
➤ DESIGN: LARIMIE GARCIA FOR GIG DESIGN

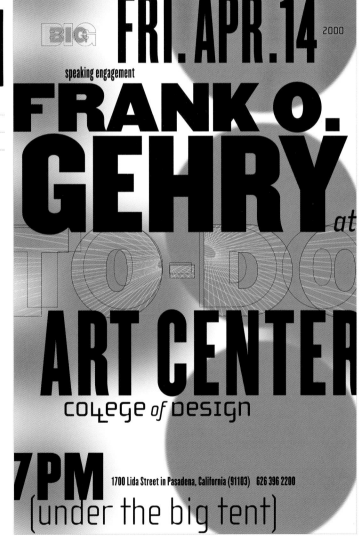

IS THIS AN announcement for a lecture by a world-famous architect, or a fight promo that should be stapled to a telephone pole? That's the fun of this design. Although Frank Gehry is indeed a well-known architect, the pugilistic vernacular of the poster acknowledges that he has had to "fight" to make his creative vision a reality.

➤ DESIGN FIRM: ART CENTER COLLEGE OF DESIGN
➤ DESIGN: DENISE GONZALES CRISP

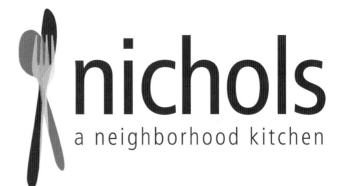

4375 Glencoe Avenue, Marina d

4375 Glencoe Avenue, Marina del Rey, CA 90292

4375 Glencoe Avenue, Marina del Rey, CA 90292 tel 310.823.2283 fax 310.823.1004

WHAT IS IT

about this identity that visually corroborates the designer's written description of the restaurant as a "friendly, neighborhood establishment"? Two very specific decisions were made to insure that the proper message is sent. The first was the choice of only lowercase letterforms in the logotype. Perhaps it is because capital letters preceded the development of lowercase letters, and because written language began as such a formal practice, that lowercase letters are allowed to be the more casual and friendly representation of language. The second visual cue is the overlapped utensils. Not only are they beautifully represented through layers of color and figure–ground ambiguity, but they are also shown in a deliberately informal arrangement, adding to the come-as-you-are message of the identity.

➤ DESIGN FIRM:
 VRONTIKIS DESIGN
 OFFICE
➤ CREATIVE DIRECTOR:
 PETRULA VRONTIKIS
➤ DESIGNER:
 TRACY LEWIS

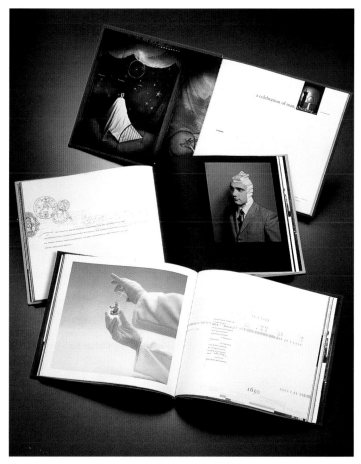

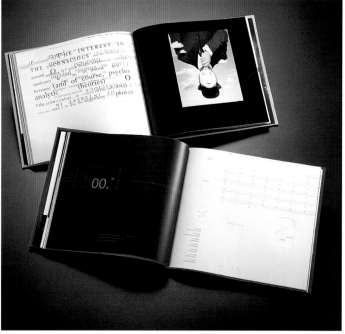

SELF-PROMOTION PIECES are often a joy to design, and this millennium calendar reflects the pleasures of working with fewer than the average number of client constraints. Throughout this calendar/book, a timeline from 0–2000 A.D. runs at the bottom of the layouts. The fine structure of the timeline complements the other more idiosyncratic elements of the layouts. The embossed calendar pages are an exercise in understatement, emphasizing the idea that this is an artifact of the millennium to be preserved, and not really a date book for listing activities and obligations.

➤ DESIGN FIRM: LOUEY/RUBINO DESIGN GROUP INC.
➤ DESIGNERS: ROBERT LOUEY, ALEX CHAO, ANJA MUELLER

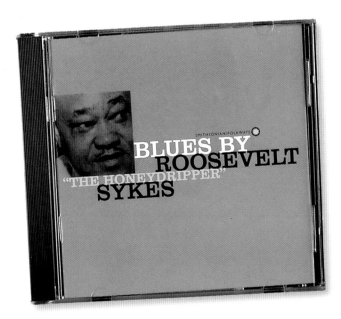

◄◄◄

THE COLORS, TYPOGRAPHY and layout of this CD cover all help locate the music in the blues era of the early 1900s. The value change in the typography allows the "Honeydripper" nickname to remain subordinate to "Roosevelt Sykes." The horizontal sliding of the type and image across the CD is, perhaps, a reference to a hand playing chords on a guitar. The warm color palette is a nice reference to the amber hue of the "honey" in "Honeydripper."

➤ DESIGN FIRM: VISUAL DIALOGUE
➤ DESIGN: FRITZ KLAETKE

IN THIS BROCHURE and map set for the Southern California
Institute of Architecture (Sci-Arc), April Greiman has combined clear information with an
image that seems as though it might be a map, but is in reality a subjective interpretation
of the Los Angeles streetscape/landscape. Both interpretations of the imagery enhance the
idea of exploration.

➤ DESIGN: APRIL GREIMAN, GREIMANSKI LABS

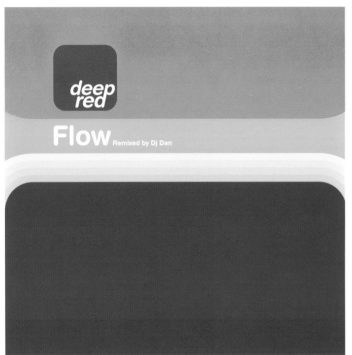

THE TECHNO-INSPIRED forms of this CD cover are at conceptual
odds with the representation of nature implied by the blue "water" element and the title of
the CD. That intrigue is supported by several visual strategies: The dark color of the small
square is repeated in the large dark area, creating figure–ground relationships, and the d
and p in the band name create a clean typographic ligature.

➤ DESIGN FIRM: SEMILIQUID
➤ DESIGNER: MIKE LOHR

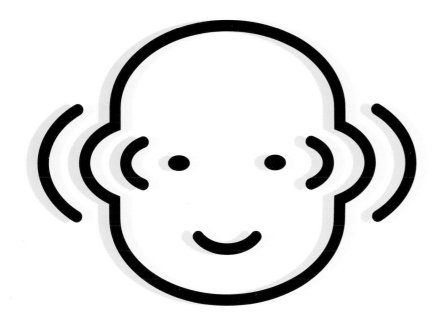

Throughout this book, the design examples have been analyzed primarily according to their chapter topic. In this final chapter, designs are explored in a more comprehensive fashion, connecting the work not only with various principles of design, but with their narrative and cultural context as well. I hope this more complete dialogue provides inspiration for you to participate in design critique on an ongoing basis. Whether in the office or on the street, start analyzing the successes (and failures) of the designs you see in the world around you. Converse with others, going beyond an agreement that the designs are bad or good: Think about what you feel and know about the design, and then work to articulate those detailed thoughts and criticisms with your peers.

QUESTIONS WORTH ASKING
What Is Design?

Design is, in many ways, the art of adding all of the extraverbal information to written language data. When we speak, our extraverbal clues of gesture, tone of voice and facial expression all add immeasurably to our ability to communicate. (Sometimes, only extraverbal information is sufficient—a smile, a nod, a fist in the air!) Technically, the manuscript of a brochure contains the same information as the designed version, and cereal tastes the same even when it is packaged in a brown paper bag, but we are rarely inspired by that level of communication. Design can augment the level of communication and the depth of information offered—but only if the data and the extraverbal elements of design (typeface, color, composition, materials) are used to transform data, it is essential that everything works together to point to the same message. A good design is either sad or happy, innocent or exotic, expensive or cheap, etc. Ask yourself if a person who couldn't read might still be able to understand the general point of your design. If the answer is yes, then all of your extraverbal information is properly directed and well designed.

I MUST ADMIT

that I am a big fan of Denise Crisp's design work. So when I told her that her recent catalog for the Art Center College of Design conjured thoughts of having dropped acid in a kimono shop, I meant it as a compliment! Crisp's use of symmetry is unexpected, and yet effective in calming down her ultra-ornate treatment of images. The kaleidoscopic repetition and highly stylized picture shapes operate in an atmosphere of reverence, not chaos, because of that restraint. The symmetry utilized in the gallery pages also helps direct the more informational, typographic portions of the catalog. While this level of visual intrigue may not be appropriate for all school catalogs, as the primary vehicle for portraying a forward-thinking design school, Crisp's exploration of visual extremes is an appropriate and inspirational pursuit.

> DESIGN FIRM:
> ART CENTER COLLEGE
> OF DESIGN
> VICE PRESIDENT,
> CREATIVE DIRECTOR:
> STUART I. FROLICK
> DESIGN DIRECTOR,
> ART DIRECTOR:
> DENISE GONZALES CRISP
> PHOTOGRAPHER:
> STEVEN A. HELLER
> ASSOCIATE DESIGNERS:
> ETHAN GLADSTONE,
> YASMIN KHAN
> EDITOR: JULIE SUHR
> PRODUCTION MANAGER:
> ELLIE EISNER
> DIGITAL PHOTOGRAPHY:
> ETHAN GLADSTONE
> AMBIENT PROSETRY:
> DEBORAH GRIFFIN

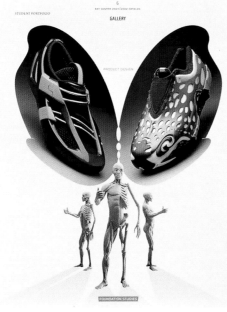

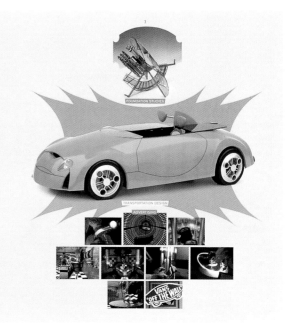

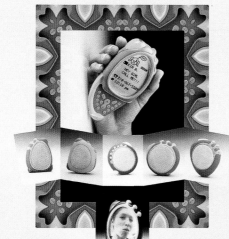

On Herman Miller

and 1992 Financial Statements of Herman Miller, Inc., and Subsidiaries

The necessity of options

Somebody once told me the only tragedy in life is to be without choices. Whether that's true or not, I would certainly say that having options—seeing them, creating them, taking advantage of them—is a characteristic of healthy organizations. Perhaps seeing and judging options is the CEO's responsibility, but I tend to think that at Herman Miller it should be everybody's job. Options make for improvement, change, and renewal.

Options are part of what we provide to our customers.

THERE IS A simplicity reminiscent of a children's schoolbook in this annual report. The size, 5½" x 8½" (14cm x 21.59cm), is smaller than the average annual report, and the crisp, clean illustrations and simple typography add a wholesome friendliness to the design. If annual reports are an opportunity to project a company's personality as well as to explain its finances, this one creates a very clear picture: Although the year's numbers were "humbling" according to the CEO, the outlook is hopeful.

➤ DESIGN FIRM: BBK STUDIO INC.
➤ DESIGN: STEVE FRYKHOLM (HERMAN MILLER, INC.), YANG KIM (BBK STUDIO INC.)

**1992 Financial Statements
Herman Miller, Inc., and Subsidiaries**

The first forefathers to arrive in America came on the *Mayflower* in 1620.

[left] Portrait of Joanna Winslow Hayward

[right] Portrait of Dr. Nathan Hayward (1761/2–1848), High Sheriff at Plymouth County. Mass. Painted by Chester Harding in 1834. "An excellent example of Harding's 1810's style—broadly painted, a well-rounded, good likeness." The portrait was $100 in 1834 and was painted when Nathan was 71–72. It remains in family hands.

MORE REMINISCENCES OF PLYMOUTH LIFE

When Grandfather (Nathan Hayward, M.D.) first married, he and Grandmother boarded with Dr. James Thacher, his brother-in-law, who lived next door. There, their first child was born, who died at thirteen days old. After this, they moved into their house where they lived until after Uncle Pelham Winslow was born (March 8, 1810) with Grandmother (Joanna Howland) White and Grandmother (Joanna White) Winslow, and Aunt Hannah White who lived in the other half of the house. They left for about ten years and then returned to this house where they both died.

Originally, Grandfather (Gideon) White lived here with Grandmother, and probably Grandmother (Joanna White) Winslow was born here, as Aunt Russell never heard of their living elsewhere, and was married from here, so Grandfather Pelham Winslow came here from Marshfield to live and was a lawyer. They went to housekeeping down in the Barnes house on North Street where they had three daughters – Aunt Mary Warren and Grandmother (Joanna), and another who died a baby. "Politics ran so high" then they, being Tories, were refused Christian burial for a time, but their friend interfered and it was granted them. In the meantime, Grandfather (Gideon) White lived here with Aunt Hannah White and his wife (Joanna Howland). (Cornelius White was hot at sea and Thomas died somewhere). Grandfather (Pelham) Winslow was obliged to leave, being a Tory, and he joined the other Tories—"A great blot on his character, but it was his honest conviction." His wife, Joanna, was confined with this last child after he left.

After the Revolution was over, he sent for Grandmother to join him as he was too obnoxious to be allowed here, and before she could get off, news came of his death. In Brooklyn, New York (1782). So poor Grandmother (Joanna White) Winslow, with her two little girls, had to come up to the old house to live. She came up here when Grandfather Winslow went off to the Tories. Grandmother Winslow took the picture gallery room and there were two desks where her little girls studied and she gave ten and breakfast in the little open fire.

Grandfather (Gideon) White was very poor and his wife (Joanna Howland) and Aunt Hannah kept a little shop in the office and sold tea. Grandmother White was a 'Facultied woman' and famous for her medical turn. She made elixirs

Family legend has it that Dr. Nathan Hayward was George Washington's Doctor.

POSTSCRIPT

I am not alone in my efforts to preserve our family's history. Yet, as I finish this book, I feel an urgency to keep the chain of information growing. There is little recorded information regarding current and recently deceased generations. It must be our charge to write down the stories we hear and the memories we have, to save letters and to keep in touch. Pictures don't necessarily share the character of individuals. If we continue with the record our forefathers began, generations that come of age centuries from now will be able to experience, with the same pleasure of discovery that I have enjoyed, whom they are descended from. I hope you will be influenced by my contribution to the family record to create one of your own.

The porch at Chilton where Granny painted many watercolor scenes.
I have one of her sketch books.

THESE EXCERPTS FROM a 138-page book is both an ambitious personal endeavor as well as a school project. The subject is the designer's family history, which is documented all the way back to the Pilgrims and the Mayflower. While conducting her research, the designer was inspired by a written description of an old family homestead—lived in by six successive generations—and its use of wooden wainscoting halfway up the interior walls. An image of wainscoting is featured as part of the binding and identifies her inspiration for dividing the layout grid in half horizontally. As with any system, its ultimate value lies in its use. In these pages, you can see how the designer utilized this unusual grid feature, which also references the timeline quality of the project. The horizontal emphasis can be seen in chapter openings, text-heavy and image-oriented layouts, and the location of the page numbers. It also inspired the decision to occasionally divide the page in half using positive and negative shapes, providing a strategy for organizing separate texts that refer to the same subject. The clean, strong lines created by the black-and-white shapes provide an interesting visual complement to this treasure of historic images and text.

➤ DESIGN: KATE RIVINUS

Develop Your Design Eye

One of the important first steps toward creating good designs is being able to identify quality graphic design in the work of others. And so in this final chapter, the seventh essential to be discussed is the development of critiquing skills. Typically, the analysis and critique of work is considered to be the domain of the art director or design instructor. While that is certainly true, it is also equally important to strengthen your own "design eye" through careful observation and analysis, no matter what your title. Through critique, you expand your visual and verbal vocabulary to eventually become your own best art director. By honing your skills of analysis on the designs of others, you will eventually have the confidence to turn those skills toward your own work. By making critical skills a standard feature of your own design process, you will always be in the process of becoming a better designer.

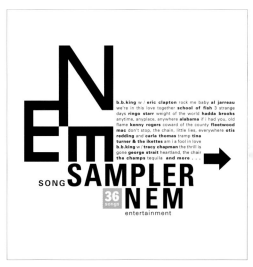

INFLUENCES FOR THE NEM entertainment identity and collateral fully span the twentieth century. The intersection of the letterforms in the logotype begin to look like enlarged pixels, while the structured design approach is reminiscent of early art and design movements such as Russian Constructivism and deStijl, both of which inspired the principles of asymmetrical balance that we use today. Here, the designer creates a sense of dynamic structure through the alignment of dominant and subordinant elements. In the stationery package, notice how the placement of the secondary type elements is often directed by the invisible guidelines established by the logotype (one example is how the line "nem entertainment corp" aligns flush left with the left stroke of the large N).

➤ DESIGN FIRM: MERYL POLLEN DESIGN
➤ DESIGN: MERYL POLLEN

["I don't believe in this

'gifted few' concept,

just in people doing things they

are really interested in doing."]

charles EAMES

["The real beginning, middle and end

is not in the plot of content, but

in the path of pursuit."]

susan YELAVICH

ACD Journal: "New Media. New Narratives?"

6 5 2 Lo

8

7

critique
&ANALYSIS

Designers make their living coming up with the best, and often most imaginative,

idea—but that doesn't mean that their idea wasn't influenced by fantastic work

already on the market. Learning to see how and why other designs communicate will

only improve your own work—opening your eyes to infinite possibilities!

.07

CHAPTER

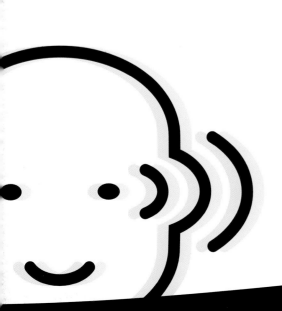

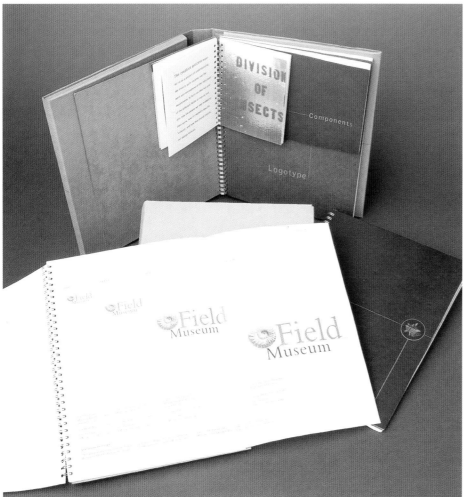

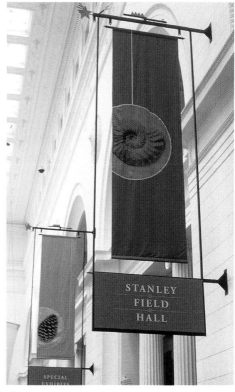

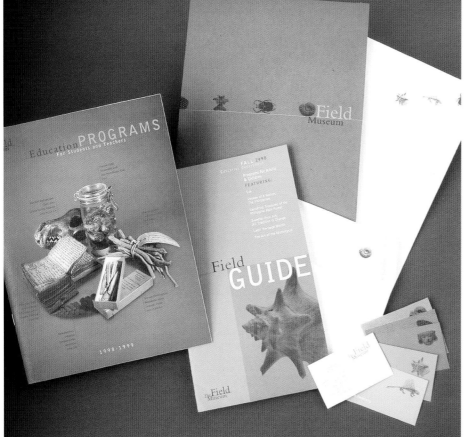

WHEN THE CLIENT *is a complex insti-
tution, such as the Field Museum in Chicago, and the
potential applications of the identity are quite varied
(banners, brochures, letterheads, press kits, etc.), an
identity must be flexible. It must address all the applica-
tions successfully and not be so rigid that its use becomes
tedious within a short time, and yet it must remain part of
a cohesive visual identity every time it is used. Here the
designers created a flexible system based on an overall
structure inspired by the Golden Section (see "Developing a
Grid" in chapter five). While the identity program and its
initial applications are by Real Design, the manuals they
created to document the museum's identity standards will
guide all designers who work on the museum's future publi-
cations and presentations.*

➤ DESIGN FIRM: REAL DESIGN
➤ ART DIRECTOR: MARGOT PERMAN
➤ DESIGNERS: MARGOT PERMAN,
 CATHERINE WOODMAN, AMY CHAN
➤ WRITER: JÜRGEN RIEHLE
➤ PHOTOGRAPHER: JOHN WEINSTEIN
➤ CLIENT: THE FIELD MUSEUM OF NATURAL HISTORY

Applications

A graphic identity is turned into an identity system through the application of the logo or logotype. The most common applications are letterhead, envelope and business card designs. Other applications often include a second sheet (for documents that run longer than one page), mailing labels and a style manual. Items such as retail signage, packaging, video labels, matchbooks, press kit folders and opening announcements are also often included as part of an identity project.

QUESTIONS WORTH ASKING

What Is a Style Manual?

Once an identity project has been completed and is no longer under the exclusive domain of the designer, there are infinite opportunities for misuse, through redesign (subtle or otherwise), use of nonapproved colors and/or unauthorized partnering with new elements. Since one of the major reasons to implement an identity program is to consistently represent a company, these abuses should be mitigated. One way to accomplish this is to prepare a usage or style manual as part of an identity project. A manual outlines the dos and don'ts of usage. It also describes the identity's application by both statement and example. In the analog days, manuals included sheets of reproducible art. Today a manual should also contain a digital file of the master art that can be used, copied and distributed. With some larger companies, an online version of the manual is part of the company's intranet, allowing all employees in all locations to access accurate reproducible art and usage information.

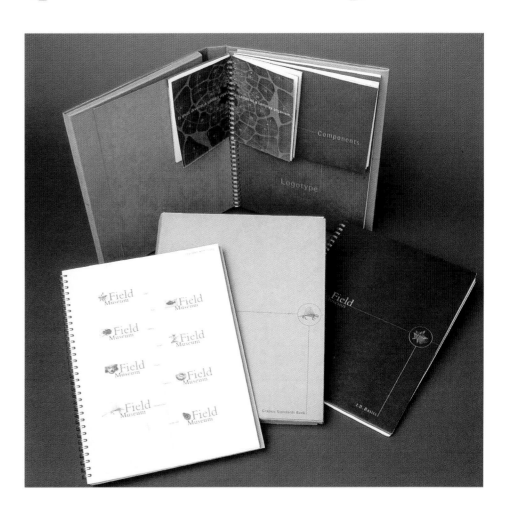

copier to resize the original art for auto-tracing into a vector-based application on the computer.

▶▶▶ Experiment with a broad range of both expected and unexpected materials. Perhaps the perfect calligraphy will be created by eyeliner on paper towels or a two-inch wide paintbrush on butcher paper. Investigating different combinations of papers and a variety of tools may yield some wonderfully unusual results.

[4] MERGE A LETTERFORM & AN ICON, OR TWO SEPARATE ICONS: This strategy is especially important with logos, and in some ways, it is the illustrative version of ligatures. Two famous examples are Paul Rand's Westinghouse W, which merges the letterform with electrical circuit imagery, and Saul Bass's Girl Scouts identity, which works three female profiles into the organization's cloverleaf identity.

Nocturnia

A MIX OF EXISTING *typefaces influenced these hand-drawn letterforms. Even though the end result is quite idiosyncratic, the formal language of bumps, divets and curls works within each letter to create a cohesive logotype.*

➤ DESIGN FIRM: ERIC GRAYBILL DESIGN

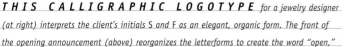

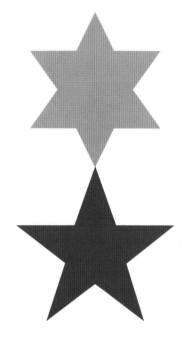

THIS CALLIGRAPHIC LOGOTYPE *for a jewelry designer (at right) interprets the client's initials S and F as an elegant, organic form. The front of the opening announcement (above) reorganizes the letterforms to create the word "open," a creative way of strengthening the visual identity established by the logotype.*

➤ DESIGN FIRM: MERYL POLLEN DESIGN
➤ DESIGN: MERYL POLLEN

IN THIS SYMBOL *for the American–Israel Public Affairs Committee, the elements are similar in form, but very different in meaning. Each star brings its own distinct politics to the logo. The visual tension created at the point where the two icons touch only enhances the references to the nature of international relationships.*

➤ DESIGN FIRM: BETH SINGER DESIGN
➤ ART DIRECTOR: BETH SINGER
➤ DESIGNER: JAMES RHOADES
➤ CLIENT: AIPAC

Four Suggested Strategies

[1] BUILD UPON AN ESTABLISHED TYPEFACE FOR A LOGOTYPE: You may recall from chapter two that every typeface has an inherent personality. This can be a particularly helpful feature to take advantage of when designing a logotype. First, typeset and print the word(s) to be incorporated into the logo at a good size for sketching (about one inch or 2.4cm high). Then use tracing paper and quickly sketch over the existing letterforms, experimenting with changes, alterations, ligatures, investigating additions/deletions, figure–ground possibilities, etc.

[2] CREATE LIGATURES: One of the goals of a typographic identity is to create an integrated sequence of letters. One way to tie the letterforms together is to create ligatures or bonded letterforms. When you are sketching your logotype possibilities, look for parts of adjacent letterforms that can be shared and or naturally woven together.

[3] GENERATE CALLIGRAPHIC ELEMENTS: Hand-generated, or calligraphic, forms are often the basis of identities. If you choose to pursue this option, two tricks of the trade may be helpful:

▶▶▶ Write the word(s) out either very small or very large. By working outside a "natural" size, the boring qualities of everyday handwriting will be left behind, and interesting visual qualities will take their place. Drawing at an unnatural scale can also be a fruitful strategy when generating illustrative elements for an identity project. When you have finished your experimentation, use a

AQUASTAR POOLS

THE AQUASTAR POOLS *identity provides insight into some important basics of logo and logotype development. The star/water image demonstrates the use of object translation through the stylized ripples as well as figure–ground relationships of the white behind the star becoming part of the water in front of it. Additionally, the use of a sharply pointed typeface creates an important formal consistency between the points on the star and the letterforms.*

➢ DESIGN FIRM: SQUIRES & COMPANY
➢ CREATIVE DIRECTOR/DESIGNER: PAUL BLACK

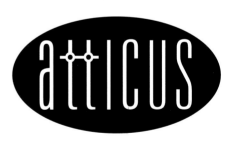

THE TREATMENT OF *the two Ts in the logotype shows the potential of combining letterforms and symbols to create an identity that is both a word and an image. In this case, the Ts connect to form a ligature that references forms found on a computer chip. The visual weight of the oval shape surrounding the letterforms provides contrast to the thin lines of the letters.*

➢ DESIGN FIRM: KIM BAER DESIGN ASSOCIATES

frizzante

THIS LOGOTYPE BEGAN *with the typeface Futura Condensed and moved on from there. Although significant effort was required to revise the letterforms, beginning with an established typeface allowed the designer to concentrate on the details that make the logotype interesting, particularly the reverse swash on the F and the customized Zs.*

➢ DESIGN FIRM: ERIC GRAYBILL DESIGN

[3] FORMALIZE VISUAL CONSIS-TENCY: Once the elements have been determined and laid out, all the parts—or forms—within the identity, including letterforms and icons, must be brought into visual agreement with one another. Even those elements purposefully different from one another must still seem to be linked.

[4] SIMPLIFY: A crucial consideration in identity design is that the final design be as graphically simple as appropriate. An identity must look good and reproduce well whether it is printed large in multiple colors or small in black and white. Thin lines, small dots and fine textures

are some of the features that may ultimately hinder an identity's usefulness. When working on the computer, it is helpful to frequently print the logo at a very small size in one color so you can assess the visual clarity of your design under less-than-perfect conditions. Examining small images is also a good way to understand how your work might read from a distance, such as on a vehicle, billboard or storefront sign.

THE ELLIPTICAL GESTURES

used to define the Regal Tea logo both render the horse image and also successfully bring to mind the steam and aroma associated with drinking tea. The form of the horse seems derived from sources such as heraldry or chess—an appropriate association for such a "regal" beverage.

➤ DESIGN FIRM: MERYL POLLEN DESIGN
➤ DESIGN: MERYL POLLEN

A Crucial Visual Strategy: Figure–Ground Ambiguity

The dynamic added to a design through the unexpected or the slightly mysterious is always of great value. Utilizing figure–ground relationships is one way to add these features to a logo or logotype. Simply put, figure–ground ambiguity is achieved when what serves as the background (ground) in one part of the composition transforms into the foreground (figure) in another part of the composition.

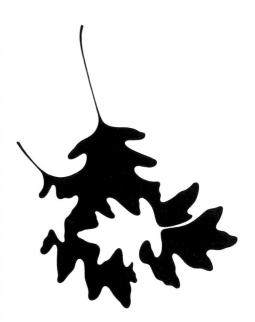

THIS EXPLORATION FOR

a park logo is an excellent example of figure–ground ambiguity as well as the theory of gestalt, which the American Heritage Dictionary defines as "a symbolic configuration or pattern so unified as a whole that its properties cannot be derived from a simple summation of its parts." In this instance, the pattern of black shapes creates both its own leaf shapes but also implies other white leaf shapes. Utilizing a gestalt design strategy helps create very cohesive visual symbols. In this case, breaking apart the components of the logo becomes visually impossible. The contrasting forms of the massive leaf shapes and the graceful stem gestures also add to the visual integrity of the design.

➤ DESIGN FIRM: MERYL POLLEN DESIGN
➤ DESIGN: MERYL POLLEN

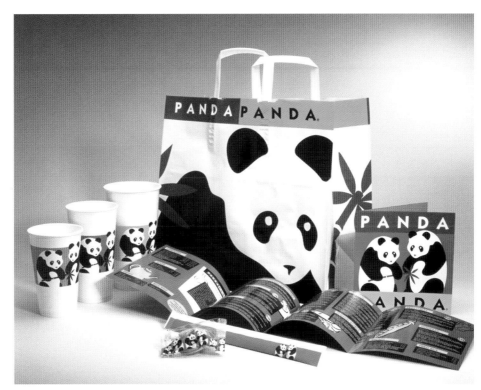

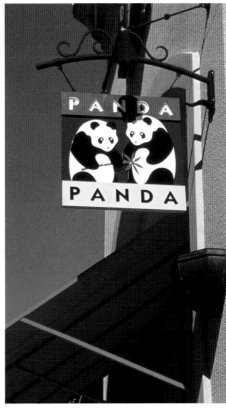

***GRAPHIC
DESIGN CAN***
*address projects ranging
from small printed pieces to
large environmental fabrica-
tions. In this restaurant
identity, the design works
in all shapes and sizes,
from chopstick wrappers to
building signage. In addi-
tion to responding well to
size constraints, the identity
is flexible enough to take
advantage of specific envi-
ronments (notice how the
logotype is above and below
the logo on the hanging
sign, but beside the logo on
the wall-mounted sign).*

*Another strength of this
identity is the object trans-
lation of the pandas' heads.
It is the bottom edges of
the ears and the black area
of the upper bodies that
defines the shapes of the
heads, helping reduce the
logo to a very simple, yet
clear, image. The use of
basic design principles con-
tinues with the shopping
bag applications where
the white background
merges with the logo to
create a successful
figure–ground ambiguity.*

➤ DESIGN FIRM:
HUNT DESIGN
ASSOCIATES
➤ DESIGNERS:
CHRISTINA ALLEN,
JENNIFER BRESSLER

THIS IDENTITY SYSTEM and logo for a strategic marketing consultant uses the thought bubble and the "sky's the limit" imagery to suggest ideas of generation and brainstorming. The horizontal emphasis in the letterforms complements the cloud/bubble imagery, and the die-cut business card helps make the ritual of card exchange more memorable.

➤ DESIGN FIRM:
 VISUAL DIALOGUE
➤ DESIGN:
 FRITZ KLAETKE,
 IAN VARRASSI

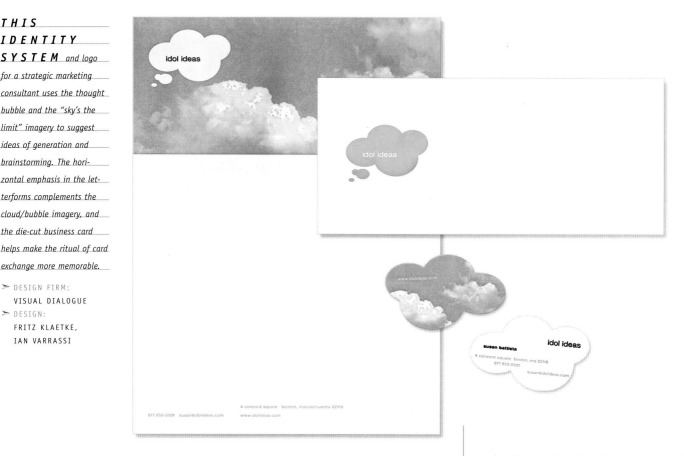

Process

Whether the strategy of the identity design is to abstract, iconicize or combine, all designs must go through a similar process to become a perfectly pure visual representation. The steps in the process are: distill, translate, formalize and simplify. All are crucial for turning an initial concept into an enduring visual identity.

[1] D I S T I L L : This involves considering all the possible images and icons that might represent the client and distilling that list down to the most promising candidates. Determining which ideas are worthy of investigation may happen through sketching (see "7 Sketching Rules" in chapter four), contemplation and/or client discussion (see chapter one).

[2] T R A N S L A T E : This stage requires working to graphically transform the selected element(s) and/or letterform(s) into ideal representations by experimenting with various illustration techniques, typefaces, forms, line weights, figure–ground ambiguity and visual attitude (for instance, a hand-drawn vs. a high-tech look). This process is sometimes referred to as object translation, which involves reworking a literal, illustrative depiction into a graphic representation of only the elements necessary to identify the image.

Three Strategies of Identity Design

Logos and logotypes either abstract, iconocize or combine visual elements to create an ideal, memorable and fast-reading graphic representation. Some examples of these strategies are:

▶▶ The Nike swoosh mark, the visual ideal of speed and grace, is not an image of one particular sport or shoe but an abstraction of the wing belonging to the mythological Greek goddess of victory. The benefit of abstraction in identity design is not only to simplify the image, but to also allow an identity to relate to multiple possibilities, hopefully all of them positive. Even if you don't know your Greek mythology, the Nike symbol conjures the idea of a wing, which in turn implies freedom and speed, and those are positive associations for the company.

▶▶ Strictly speaking, an icon is any representation or symbol. But with an iconic identity, the goal is to raise an ordinary visual representation to the highest possible level of instant recognition and positive association. For instance, the Red Cross symbol (which is really just a red "plus" sign) can bring to mind thoughts of emergency assistance and compassion. In design, the careful selection, isolation and representation of icons can propel an identity to a new level of recognition and cultural importance.

▶▶ The IBM logotype by Paul Rand is a surprisingly simple, yet enduring, representation of digital information that combines a striped pattern of lines (the "on/off" of binary code) and the three letters of the company's full name (International Business Machines).

In a more notorious example, the typeface Crack House and all the logotypes that were spawned from it, combines simple sans serif letterforms with the horrors of decay.

Often these strategies merge. In the case of the Apple computer logo, the icon of an apple (representing education) is combined with the pattern of a rainbow (representing hope and luck). Although a common idea today, when Apple started out, the notion of a friendly computer was almost unbelievable, which was why an optimistic identity was such an essential element of the company's image and marketing scheme.

94

QUESTIONS WORTH ASKING

What Is the Difference Between a Logo and a Logotype?

While it is common to mix up these terms or use them interchangeably, a logotype is an identity that features a word or multiple letters, often with an icon or illustration embedded within the letterforms. A logo is a nonverbal iconographic identity. Some identities consist of one or the other; others incorporate both.

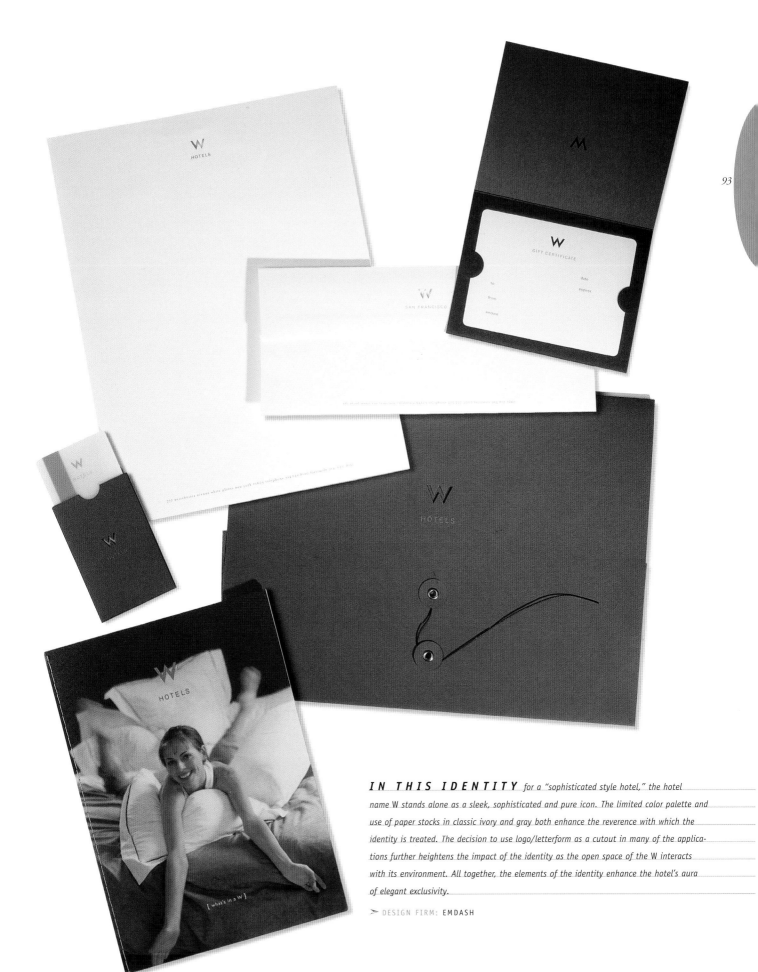

IN THIS IDENTITY *for a "sophisticated style hotel," the hotel name W stands alone as a sleek, sophisticated and pure icon. The limited color palette and use of paper stocks in classic ivory and gray both enhance the reverence with which the identity is treated. The decision to use logo/letterform as a cutout in many of the applications further heightens the impact of the identity as the open space of the W interacts with its environment. All together, the elements of the identity enhance the hotel's aura of elegant exclusivity.*

➢ DESIGN FIRM: EMDASH

The Image of Perfection

A graphic identity is a symbolic idealization of a company, service or retail establishment. When the ancient Greeks pondered the visual ideal (although they probably weren't thinking of logos and logotypes!), they wondered how things could be identified when every example of any particular item was different. How could anyone be sure that an elm tree was an elm tree when there was no single absolute as to what an elm tree should look like? One conclusion was that every example within a group shares an identical *ideal essence*. It is this essence that people register and use to identify the things around them. Throughout the process of developing an identity, graphic designers seek out that essence and utilize the ideal as the ultimate identity tool.

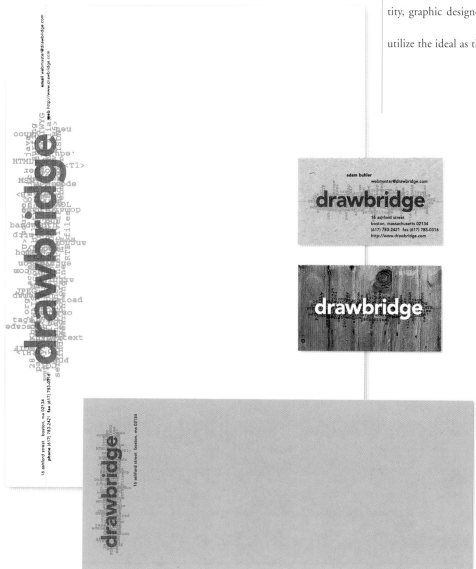

THIS IDENTITY FOR a Web programming and consulting firm eschews the typical swoopy/global imagery of internet firms and instead opts to use the word "drawbridge" to metaphorically "span a moat" of muddled Web lingo (the orange type). Scale and value keep the company name visually separate from the background typographic image, promoting the idea that this company is above the fray.

➤ DESIGN FIRM:
VISUAL DIALOGUE
➤ DESIGN:
FRITZ KLAETKE

92

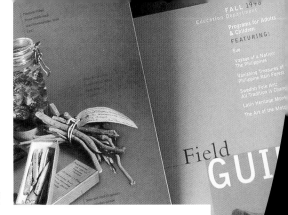

[*"[Take] a minimal amount of material and a minimal amount of effort—nothing wasted— to achieve maximum impact."*]

lou
DANZIGER

as quoted in the AIGA's Graphic Design Annual: 19

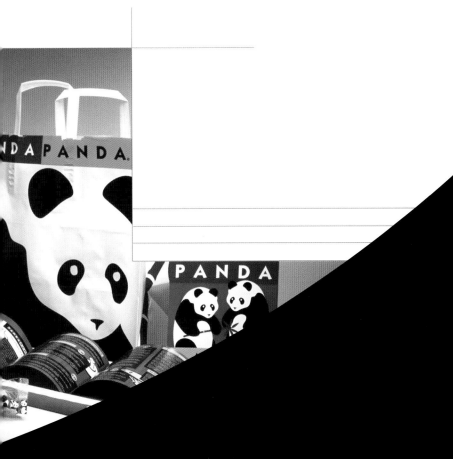

identity
DESIGN:
logo & logotypes

Recognition is what every company or organization wants. Clients want you, the

designer, to develop a highly recognizable representation of their company—something

that encapsules everything they want to be. It's an exciting challenge, and with the tips

in this chapter, you're well on your way to stellar logo and logotype design.

CHAPTER .06

Graduate Studies in
Cell and Developmental Biology
—
HARVARD MEDICAL SCHOOL

flexibility,

excitement,

excellence,

with

opportunities

for

interdepart-

mental

training

in a

broad range

of research

areas.

Cell and Developmental Biology–Harvard Medical School (CDB-HMS) is an interdepartmental program within the Division of Medical Sciences at Harvard Medical School. Through the Division of Medical Sciences, CDB-HMS recommends its candidates to the Faculty of Arts and Sciences of Harvard University for the PhD degree in Cell and Developmental Biology (Medical Sciences). The faculty of the program is diverse, coming from all the preclinical departments of the Medical School and a number of affiliated teaching hospitals and institutions. Among these are Children's Hospital, Dana-Farber Cancer Institute, Brigham and Women's Hospital, Beth Israel Hospital, Joslin Diabetes Center, the Deaconess Hospital, Massachusetts General Hospital, and the School of Public Health.

CDB-HMS offers interdisciplinary research training in basic cellular processes, the properties that enable cells of higher organisms to form tissues and organs, and in the molecular processes that underlie the development of complex organisms. The research activities of the program faculty and students are concentrated in one or more of the following areas:

- Cellular structure, architecture and function
- Cell-cell and cell-matrix interactions
- Regulation of gene expression - in development and differentiation
- Control of cell proliferation
- Genetic control of development

The methods and experimental approaches used to address questions within these areas cover a wide range and include the techniques of molecular biology, protein chemistry, morphology, biophysics and molecular and developmental genetics. The research of the program faculty and student is aimed at elucidating normal mechanisms, but may well take advantage of sharper questions raised by pathological conditions, such as hereditary abnormalities and neoplastic processes.

ALFRED L. GOLDBERG

DEPARTMENT OF CELLULAR AND MOLECULAR PHYSIOLOGY

Our laboratory is presently engaged in studies of the regulation and mechanisms of protein breakdown in animal cells, especially skeletal muscle and reticulocytes, as well as bacteria. These problems are being investigated by biochemical, physiological, and genetic approaches. One important function of intracellular protein breakdown is to selectively eliminate highly abnormal proteins, as may result from mutations, mistakes in gene expression, and postsynthetic damage. Such proteins and various short-lived regulators proteins are rapidly hydrolyzed by a soluble ATP-dependent pathway whose mechanisms are being studied. Prior work has shown that critical components of this pathway in animal and bacterial cells are new types of proteolytic enzymes that require ATP hydrolysis for activity. A major goal is to understand the function of these large, multimeric proteases, the role of ATP, and their ability to recognize and selectively degrade abnormal proteins. In mammalian cells we are presently attempting to clarify the structure and function of three recently discovered ATP-dependent proteolytic complexes: the 700-kDa proteasome, the 500-kDa Da multipain, and the 1500-kDa ubiquitin-conjugate-degrading enzyme. Related studies concern the involvement of heat-shock proteins and ubiquitin in intracellular proteolysis and the regulation of cellular protease content in bacterial and animal cells.

Intracellular protein breakdown is also an important factor in determining cell growth or atrophy and is activated in fasting to provide essential amino acids. A primary objective of the work in this laboratory is to understand how hormones (e.g. glucocorticoids or insulin), food supply, contractile activity, or disease processes (e.g. monokines) increase or suppress overall protein breakdown in skeletal muscle. Mammalian cells contain at least four different cellular pathways by which proteins are degraded; however, the specific functions of these different degradative processes and the biochemical mechanisms regulating their activities are unclear. Recent studies with isolated muscles indicate that in fasting, infection, or upon denervation, the soluble ATP-ubiquitin-dependent degradative process is activated, and this accelerations of proteolysis leads to muscle wasting. A major goal of this research in coming years is to elucidate the biochemical and genetic basis for these changes in overall protein turnover.

Goff, S.A. and Goldberg A.L. 1985. Production of abnormal proteins in E. coli stimulates transcription of lon and other heat-shock genes *Cell* 41 587-595.

Matthews, W. Tanaka K., Driscoll, J. Ishihara A. and Goldberg, A.L. 1989. Involvement of the proteasome in different degradative processes in mammalian cells *Proc. Natl. Acad. Sci. USA* 86 2597-2601.

Fututia N. Goodman, M.N. and Goldberg, A.L. 1990 Role of different proteolytic systems in the degradation of muscle proteins during denervation atrophy *J. Biol. Chem* 265 8550-8557.

DIFFERENT FUNCTIONAL ROLES OF THE PROTEASOME IN PROTEIN DEGRADATION

MARY B. GOLDRING

DEPARTMENT OF MEDICINE

We study the control of collagen and collagenase gene expression by inflammatory mediators in human connective tissue cells in vitro. Chondrocytes are capable of participation in breakdown of their own matrix in response to inflammatory mediators and in repair of the damaged collagen network. We have established a cell culture model employing cultured human chondrocytes as target cells for cytokines such as interleukin-1 (IL-1), interferon-γ (IFN-γ), tumor necrosis factor (TGF) and transforming growth factor-β (TGF-β). We found that IFN-γ suppresses synthesis of cartilage-specific type II collagen as well as types I and II collagens and fibronectin and leve ls of cellular procollagen mRNAs in chondrocytes. IL-β, stimulates synthesis of PGE₂ and collagenase. It also increases synthesis of types I and III collagens and levels of associated procollagen mRNAs when the synthesis of PGE₂, which inhibits collagen synthesis is blocked by a prostaglandin synthetase inhibitor. In contrast, IL-1 suppresses levels of cartilage-specific types II and IX collagen mRNAs thereby inducing loss of cartilage phenotype. TNF and TGF-β have similar and/

or synergistic effects with IL-1, and phorbol ester mimics some of the effects of IL-1. To further define the mechanisms by which these ligands controls synthesis of collagen, we have undertaken studies of their effects on both signal transduction and transcription. Potential signal transduction mechanisms are investigated by comparing the effects of IL-1 and phorbol ester on cAMP-dependent pathways. The control of collagen gene transcription is studied: (1) by assessing nuclear transcription *in vitro*, (2) by measuring expression of collagen gene promoter constructs transfected into mammalian cells; and, (3) by analyzing *cis*-acting DNA elements in 5'-flanking regions of type I and type II collagen genes and potential *trans*-acting DNA binding proteins inducible by cytokines by gel retardation and DNA footprinting assays. Initial studies have focused on phorbol ester- and cAMP-inducible elements. These studies will provide information on how cytokines modulate matrix turnover in cartilage, synovium and other connective tissues in inflammatory conditions.

Goldring, M.B., Sandell, L.J., Stephenson, M.L. and Krane, S.M. 1986. Immune interferon suppresses level of procollagen mRNA and type II collagen synthesis in cultured human articular and costal chondrocytes. *J. Biol. Chem.* 261 9049-9056.

Goldring, M.B., and Krane, S.M. 1987. Modulation by recombinant interleukin 1 of synthesis of types I and II collagens and associated procollagen mRNA levels in cultured human cells. *J. Biol. Chem* 264 16724-16729.

Goldring, M.B., Birkhead, J., Sandell, L.J., Kimura, T., and Krane, S.M. 1988. Interleukin 1 suppresses expression of cartilage-specific types II and IX collagens and increases types I and III collagens in human chondrocytes. *J. Clin. Invest.* 82 2026-2037.

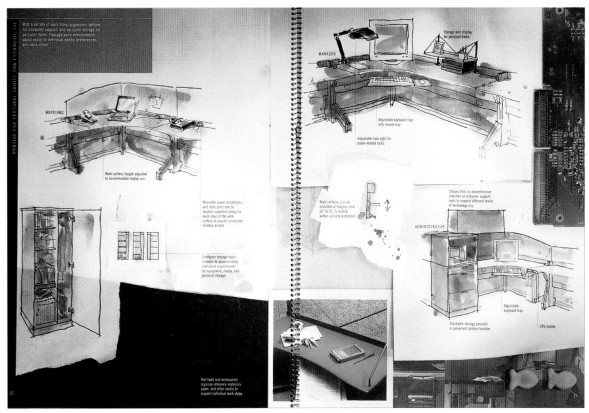

MATERIALS PLAY AN *important part in this design. The translucent light blue cover has only two elements printed on it (the small title at the lower left and the Herman Miller logotype reversed out of the blue). The rest of the composition shows through the translucent plastic of the cover from an underlying page. The simple grid that organizes the type behind the cover continues inside the book. The crisp, clean modules and elegantly restrained type are offset by smudges of paint that are eventually revealed to be parts of sketches that experiment with thoughts on how the furniture might ultimately be organized. The difference between the objective furniture information and the subjective furniture arrangements are played out through the visual contrasts of the design.*

➤ DESIGN FIRM: BBK STUDIO INC.

1/50 *Life.* Child mortality in 1960 was 250 deaths per 1,000 births in the developing world. Today it is 100.

THE THEME OF this annual report for the international relief organization CARE is "50 reasons to believe in the next 50 years." The reasons are highlighted throughout the publication and always set in oversized type. Each reason is set flush left and spans the width of the page. The body copy is organized according to a grid that divides the page into two main columns, with an overlapping third column centered between the first two that is used for subheads and other highlighted information. The full-bleed photographs and large type contrast well with the thin rules and classic typographic attitude of the text-heavy pages.

➤ DESIGN FIRM: WAGES DESIGN
➤ ART DIRECTOR: BOB WAGES
➤ DESIGNER: RORY MYERS

EMERGENCIES

Emergencies Director: Tom Alcedo
40 projects in 15 countries 5,098,000 people assisted; 8,855,000 indirect beneficiaries.

Fifty million refugees and displaced people suggest that the world is becoming a more dangerous place to live. The end of the Cold War and the resurgence of ethnic strife have brought more than 80 armed conflicts, while natural catastrophes continue to hit the people of developing countries particularly hard. Aftereffects are long-lasting, undoing years of progress. CARE works to anticipate disasters, respond quickly to save lives, and help people get back on their feet. In 1995, CARE provided emergency assistance to nearly 15 million people worldwide. | RWANDA | CARE supplied food, shelter materials and farming supplies to 1.3 million returning refugees, internally displaced people and impoverished local residents. | TANZANIA | We distributed food and provided sanitation and health care to some 450,000 Rwandan refugees housed in the Benaco and Muuuhura Hill camps. | SUDAN | CARE managed camps for 24,000 people displaced by civil war in the south. | AZERBAIJAN | We supplied food to 120,000 refugees from Ngorno Kharabach and more than 300,000 Azerbaijanis

uprooted by the war with Armenia. | BOSNIA | CARE provided medical assistance, safe water, food and warm clothes to abandoned and isolated elderly, disabled children and survivors of violence. | HAITI | CARE-managed food programs reached more than 600,000 people each week – one-tenth of the population. | In all relief operations, CARE's goal is to move as quickly as possible from disaster relief to rehabilitation and then to long-term development. This may come in the form of better roads and increased crop production in drought-prone Ethiopia, the development of loan programs for poor farmers and microentrepreneurs in war-torn Sri Lanka, or the provision of seeds and tools to returning Rwandan refugees. CARE knows that what disaster survivors need most – aside from food, medical care and shelter – is the restoration of hope.

14/50 *Munyantwali Valens,* a Rwandan refugee. "Myself and my family have lost much. But when our two sons awake in the morning and they are eager to fetch water or firewood, we can still feel some hope. For these things we thank CARE."

15/50 *Safety.* The threat of nuclear war is less today than at any time in the nuclear age.

CARE USA NOTES TO FINANCIAL STATEMENTS
30 June 1995 and 1994

NOTE 1. Organization
CARE USA is an independent not-for-profit cooperative organization founded in 1945. CARE USA is a member of CARE International, an umbrella organization which coordinates the program activities of the CARE International member organizations. In the regular course of its operations, CARE USA makes certain grants to CARE International and its member organizations and receives certain funding from other members of CARE International.

NOTE 2. Summary of significant accounting policies
Basis of Accounting
The accounts of CARE USA are maintained in accordance with accounting principles generally accepted in the not-for-profit industry. Net assets are categorized as follows:

Unrestricted Net Assets
Within the unrestricted net assets are the following types of net assets (formerly referred to as fund balances):

— *Commitments for Ongoing Programs.* This represents net assets committed to program activities in a fiscal year which are unspent at year-end. These net assets are available in the following fiscal year to continue the specific program activity.
— *Board-Designated Endowment.* CARE USA's Board of Directors has designated that certain bequests be created as quasi-endowment net assets. The income from the net assets is available for use in disaster and emergency programs. For the year ended 30 June 1995, an additional $4,800,000 was allocated to board-designated endowment net assets.
— *Investment in Property and Equipment.* This represents the carrying value of CARE USA's fixed assets.
— *Undesignated.* This represents net assets that are fully available, at the discretion of CARE USA's management and Board of Directors, for CARE USA to utilize in any of its programs or supporting services.

Temporarily Restricted Net Assets
Contributions which are received with donor-imposed temporary restrictions are classified as temporarily restricted. Within the temporarily restricted net assets are the following types of net assets:

— *Donor Contributions–Special Appeals.* Contributions received in response to appeals to the general public for specific activities (usually emergencies) are considered restricted until the proceeds are used for that specific activity.
— *Donor Contributions–Project-Specific.* Contributions received for use in a particular CARE USA development or emergency project are restricted for use in that project.
— *Investment Income/Gains on Endowment Funds.* The net investment income/gains on endowment (permanently restricted) funds are restricted for use in certain activities. In addition, some temporarily restricted contributions specify that the net investment income/gains earned on their funds be used for certain activities.

Permanently Restricted (Endowment) Net Assets
CARE USA's Board of Directors authorized the establishment of CARE USA's endowment net assets. CARE USA's endowment net assets are divided into specific program sectors. Income earned on the net assets is temporarily restricted for use in CARE USA's programs in the specific sectors.

Cash and Cash Equivalents
Cash and cash equivalents include demand and time deposits. CARE USA considers all highly liquid investments with a maturity of three months or less when purchased to be cash equivalents. Restricted cash includes contributions with donor-imposed restrictions. There were $5,994,000 and $2,362,000 in restricted cash for the years ended 30 June 1995 and 1994, respectively.

37/50 *Costa Rica.* It spends less on its military and more on health and education than any nation in Latin America. And has the highest quality of life. In 1996, CARE will end work there after 38 years.

CARE USA NOTES TO FINANCIAL STATEMENTS
30 June 1995 and 1994

Investments
Investments are presented in the financial statements at the lower of aggregate cost (amortized cost, in the case of bonds) or fair value as determined based on their quoted market prices. Donated stocks are valued at the fair value at the date of receipt. Restricted investments include contributions with donor-imposed restrictions. There were $7,062,000 and $6,371,000 in restricted investments for the years ended 30 June 1995 and 1994, respectively.

Property and Equipment
Property and equipment are recorded at cost if purchased or, if donated, at the fair value at the date of the gift, less accumulated depreciation. Depreciation is provided on the straight-line basis over the estimated useful lives of the assets, which are 15 years and 3 years for buildings and equipment, respectively. Equipment acquired for direct use in programs is expensed in the year of acquisition.

Contributions and Donated Services
Agricultural and other commodities received at no cost from agencies of the U.S. Government, the United Nations and several other countries for distribution under contracts related to special relief programs are recorded at an ascribed amount representing the market valuation. CARE USA received 438,000 and 369,000 metric tons of such commodities in the years ended 30 June 1995 and 1994, respectively.
— Contributions-in-kind for use in assistance programs are recorded at fair value. Government and local communities in countries in which CARE USA operates contribute labor, technical services, materials, transportation and storage facilities under various programs in which they participate with CARE USA. The value of most of these contributions is not reflected in the accompanying financial statements because of the difficulty of measurement and because the contributions are generally not subject to CARE USA's control. Similarly, the value of space and time contributed by various media for public information and fund-raising campaigns is not reflected in the accompanying financial statements because it is not subject to control or reliable measurement.

Agricultural commodities and contributions-in-kind are recorded as support upon receipt and as an expense (*program activity*) when shipped to overseas destinations.

— Unrestricted contributions received from the public are recognized as revenue when received. All contributions are considered available for unrestricted use unless specifically restricted by the donor or received in response to specific solicitations.
— Contributions received as a result of a specific solicitation to the general public are classified as temporarily restricted and are recorded as revenue in the year of receipt.
— Upon signature of the annuity contract, it is CARE USA's policy to recognize as revenue the present value of the estimated remainder of an annuity contract. CARE USA recognized approximately $801,000 and $866,000 of unrestricted revenue for the years ended 30 June 1995 and 1994, respectively.
— Contributions to the permanently restricted net assets (*endowment fund*) are recognized as income in the year of receipt.
— Bequests are recorded when the amounts are determinable and collection is reasonably assured.

Accounting for Contributions
In 1993, the Financial Accounting Standards Board issued Statement of Financial Accounting Standards No. 116, "Accounting for Contributions Received and Contributions Made." Among other things, this statement requires the recognition of pledges as revenue upon receipt of the pledge and using discount factors for recording long-term pledges. CARE USA will adopt the new standard effective 1 July 1995. CARE USA will adopt the new accounting method by recording a cumulative catch-up adjustment in the year of adoption. Management has not yet quantified the effect of the adoption on CARE USA's financial statements.

38/50 *Dr. Raul Cadena.* He joined CARE Ecuador in 1962 as an office assistant. Today he is Assistant Director. 94% of CARE employees are national staff at work in their own countries.

Grids Cannot Live by Lines Alone!

In all uses of grids, the "invisible" lines that form the grid are only part of the formula for imaginative design consistency. Design decisions regarding details such as typography, color and use of photography should all be included in the delineation of an overall system. Visual decisions, partnered with structural decisions, fortify the reason for using a grid in the first place. The following examples explain why this consistency is at the heart of grid use.

▶▶▶ In information design, paying strict attention to typographic consistency means that all the states, cities and other identifications on a map must be labeled in a consistent typographic manner, or that timetables employ a consistent use of different typographic weights to distinguish different aspects of the content.

▶▶▶ In stationery packages, consistent color and typographic and layout decisions from piece to piece bring together designs that might otherwise not relate to one another because of their size and function.

▶▶▶ With magazine layouts, consistent typographic treatment of one element, such as body copy, paves the way for a less rule-bound treatment of other special elements, such as headlines and introductions. You might think of this in orchestral terms: In a musical arrangement, certain instruments play a steady foundation of notes and rhythms so that the soloist can be the star. Even in jazz innovation, there is often a set series of chords from which the musicians improvise. The same sort of balance between things that change—and things that don't—is a crucial decision in multipage design.

QUESTIONS WORTH ASKING

How Can I Keep Layouts Interesting Page After Page?

While there are some multipage projects that shouldn't vary much from page to page (dictionaries, for instance), other projects such as magazines, newsletters and brochures need to develop a rhythm in order to maintain their audience. This is often referred to as sequential design. Sequential design is the page-to-page rhythmic balance between elements that change and those that do not. Imagine a trip to Paris. Museums were interesting for three days in a row, but you now feel the need to change your daily rhythm a bit. You spend a day shopping or relaxing in the Luxembourg Gardens before spending the final day of your trip visiting museums once again. As with travel itineraries, the key to sequential design is to know when to keep a layout in its pure state, and when to take a break.

When planning a complete sequence of pages, it's best to start by getting all the elements into their preliminary position according to the basic grid plan, and adjust from there. Analyze the sequential design by turning the pages (in this case, printed pages are better than looking at everything on the computer screen). Try to feel when a spike in the visual action is required. Create exceptions to the basic design to the extent that they are necessary, but not so often that they will undermine the beauty of the design structure. Remember: Establishing the expected is the first step in creating unexpected, visually rhythmic layouts.

QUESTIONS WORTH ASKING

What Happens When a Grid Doesn't Accommodate a Particular Situation?

No grid is sacred, and the occasional intelligent, purposeful disruption of the grid can help 1) solve a unique layout problem, and 2) create some excitement within the system. A tip that may help when purposefully breaking the grid is to do so within the same spirit that the grid was devised. For instance, using half of the measure of the existing column width to create a new vertical grid line is a technique that both uses/doesn't use the grid. One word of caution: If you find yourself consistently breaking the grid, then maybe it's time to either reconsider some of your grid design decisions, or incorporate that frequent need into the system itself.

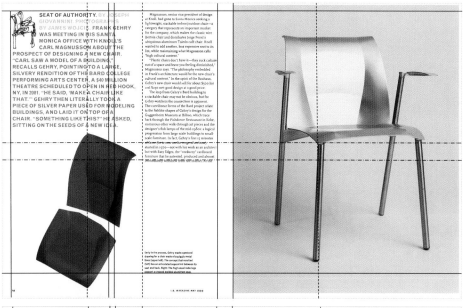

SEAT OF AUTHORITY. BY JOSEPH GIOVANNINI. PHOTOGRAPHY BY JAMES WOJCIK. FRANK GEHRY WAS MEETING IN HIS SANTA MONICA OFFICE WITH KNOLL'S CARL MAGNUSSON ABOUT THE PROSPECT OF DESIGNING A NEW CHAIR. "CARL SAW A MODEL OF A BUILDING," RECALLS GEHRY, POINTING TO A LARGE, SILVERY RENDITION OF THE BARD COLLEGE PERFORMING ARTS CENTER, A $40 MILLION THEATRE SCHEDULED TO OPEN IN RED HOOK, NY, IN 2001. "HE SAID, 'MAKE A CHAIR LIKE THAT.'" GEHRY THEN LITERALLY TOOK A PIECE OF SILVER PAPER USED FOR MODELING BUILDINGS, AND LAID IT ON TOP OF A CHAIR. "SOMETHING LIKE THIS?" HE ASKED, SITTING ON THE SEEDS OF A NEW IDEA.

Magnusson, senior vice president of design at Knoll, had gone to Santa Monica seeking a lightweight, stackable indoor/outdoor chair—a category that represents an important market for the company, which makes the classic wire Bertoia chair and distributes Jorge Pensi's ubiquitous aluminum Toledo café chair. Knoll wanted to add another, less expensive seat to its list, while maintaining what Magnusson calls "high cultural content."

"Plastic chairs don't have it—they suck culture out of a space and leave you feeling diminished," Magnusson says. "The philosophy embedded in Frank's architecture would be the new chair's cultural content." In the spirit of the Bauhaus, Gehry's new chair would sell for about $500 list and $250 net: good design at a good price.

The leap from Gehry's Bard building to a stackable chair may not be obvious, but for Gehry-watchers the connection is apparent. The curvilinear forms of the Bard project relate to the fishlike shapes of Gehry's design for the Guggenheim Museum at Bilbao, which trace back through the Fishdance Restaurant in Kobe, numerous other walk-through art pieces and the designer's fish lamps of the mid-1980s: a logical progression from large scale buildings to small-scale furniture. In fact, Gehry's first 15 minutes of fame (which predates his current fame) started in 1970—not with his work as an architect but with Easy Edges, the "corduroy" cardboard furniture that he patented, produced and almost immediately withdrew from the market. To say

Gehry in the process. Gehry made a gestural drawing for a chair made of squiggly metal lines (upper left). The concept that resulted (left) has an articulated separation between its seat and back. Right: The Fog's steel-tube legs support a creased molded-aluminum seat.

THE SKILLFUL USE of scale, typography and asymmetrical balance belie the simplicity of the grid that guides feature articles in I.D. Magazine. As shown by the overlay lines, the grid's foundation is two equal-width columns per page, offset by the use of a narrower column as desired. Custom layout decisions, such as the choice to let the introductory type run past the standard column width, or the use of a full-bleed photograph, help individualize each article. Because such decisions are made sparingly, they add interest without undermining the grid's ability to help visually unify the entire magazine, issue after issue. (Creating overlay lines to show the the grid pattern is a way to "reverse engineer" a respected layout. See page 81 for more on reverse engineering.)

➤ DESIGN FIRM: I.D. STAFF
➤ DESIGN DIRECTOR: LUKE HAYMAN

85

Gehry worked through models in various materials, including silver paper (left and bottom) and stainless steel (right) in search to find the seat angle that would optimize comfort.

inventor." With the Frank Gehry Collection, Gehry had already accepted Knoll's marketing mechanisms, which made his name a company brand. "But Knoll is architect-oriented and continues in a tradition that includes Mies and Breuer," Gehry says. If it's a cult, it's one he doesn't mind belonging to.

The question of whether a "Gehry chair" would result from a more streamlined development process remained, however, as the industrial process has a tendency to sand smooth the irregularities that characterize Gehry's aesthetic. He was now venturing into unfamiliar territory.

Gehry's first idea was based on a gestural drawing that translated into a chair of squiggly metal lines, as though drawn in space. Unfeasible at a reasonable cost, the exploration quickly returned to one of metal planes, like the seat Gehry had improvised with silver construction paper. From Easy Edges to the Gehry Collection, the architect had conceived his furniture as unitary pieces that integrated seat and structure, but the demands of the new chair required a different approach. Its nature was complex: It had to stack and work indoors and out—"things no one ever does with a chair anyway," Gehry jests. His solution created a separation between the supporting and supported elements.

Because a single continuous curvilinear or continuous back and seat would have required too expensive a mold and increased the chair's price, Gehry came up with a segmented design that articulates the separation between its shell, seat and back. The Eames "potato chip" chair is never far from the minds of furniture designers especially when dealing with segmented shell forms. Using aluminum, Gehry was mining territory at a safe distance from the Eameses; he further distinguished his design from theirs by tacking the near edges of the seat and back together into a structural fulcrum that gives gently when a person leans back. Ribs and creases articulate the forms, giving them structural rigidity and allowing them to thin where desirable and thicken where necessary, keeping the chair visually compelling and lightweight. Its two segments, joined at their intersection, are supported by stainless-steel tube legs from which armrests spring.

COULD A MORE STREAMLINED PROCESS ACTUALLY RESULT IN A GEHRY CHAIR?

Like the best of Gehry's work, the chair is unexpected. The design may have devolved from the building that evolved from the fish, but it looks like another. Nor does it resemble any of the other furniture pieces in Gehry's collections: It does not try to be as endearing and clever as Easy Edges, nor is it as spatially complex as Rough Edges or the Gehry Collection. The new chair, to be introduced this June at Neocon and known as the Fog (Gehry's initials), is simple and terse—a succinct statement made in a few brief lines. Gehry has manipulated the design so that the form and material are working together in ways that simplify production. The Fog (which will be followed eventually by a table and bar stool) is taut and, unlike most of Gehry's expressive work, almost minimal. Since the chair is intended for outdoor use by cafés and restaurants where it will appear in clusters, "you don't want it to seem self-conscious," Magnusson explains. "That's why we're working with the Fog name—you'll see a lot of them as a random pattern."

Ironically, Gehry has come back almost full circle to Easy Edges—and to the Bauhaus principle—in his achievement of a relatively inexpensive chair. At $250 net, the Fog may not be a Volkswagen, but it is far from the Cadillacs that the great Knoll classics, like the Mies pieces, have become. And Knoll can count on at least one satisfied customer. Gehry says he'll be using the chair in the Condé Nast cafeteria he's designing in New York.

Joseph Giovannini is a New York and L.A.-based writer and architect.

The finished Fog, a succinct statement at a good price.

time, he felt that his notoriety as a furniture designer was eclipsing his reputation as an architect, and he disliked the demands the marketing program made. The chair's investors were trotting Gehry out to sell his "signature" designs in a series of PR campaigns that traded on his personality. "I was freaked about going on the road and being marketed like Yves St. Laurent," he says. "It was a cult." Within a few months, Cosmopolitan magazine had even featured him as "Bachelor of the Month."

It has been nearly 30 years and many chairs since Gehry made his peace with furniture. After Easy Edges, he went on to Rough Edges, another line of cardboard chairs, whose raw, precarious forms challenged notions of repetitive, modular, low-cost industrial design. Rough Edges crossed the line into art furniture, and was sold at galleries rather than in showrooms.

In the Frank Gehry Collection, a series of nine pieces he designed for Knoll in 1992, the architect pursued his interest in working hands-on with unorthodox materials. Inspired by the wooden slats of fruit crates, Gehry produced a collection of sculpted forms that became per-

objects in upscale offices and homes. "It was important to make a furniture a reality, and I'm pleased to say we made money on it," Magnusson says of the collection. "It reconfirmed our commitment to design experimentation."

Like an artist/sculptor rather than an industrial designer, Gehry cultivates an immediate physical relationship to the object he's developing, rather than one based on drawings on paper. Beginning with scores of sketch models, some full-size, he comes to understand the properties of the materials he engages.

"I made some of the Easy Edges pieces with my own hands, the way I make models for buildings," Gehry says. "I cut pieces off and tack them on to compose visually in real time and space." Working in full-scale models with wood slats and cardboard encouraged a tactile sensibility common to the Gehry Collection, Rough Edges and Easy Edges.

Magnusson's proposal for a single chair with a low production cost—a cost dependent on a simple form, uncomplicated manufacturing process and high-volume tooling—could not be realized practically with Gehry's usual immersion method. Instead, the designer adopted a more pragmatic approach: "I wanted to see if I could work within Knoll's parameters, without a shop," he says. "Everything I've always done has been a reaction against the usual expectations of the furniture market. This time, I wanted the chair to come out of my own work, the shapes of my buildings, but I wasn't trying to invent so much. I was setting more as shepherd than

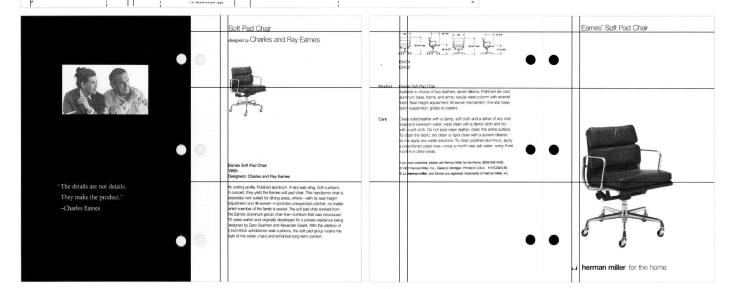

Soft Pad Chair
designed by **Charles and Ray Eames**

"The details are not details. They make the product."
–Charles Eames

Eames Soft Pad Chair
1969–
Designers: Charles and Ray Eames

An inviting profile. Polished aluminum. A taut seat sling. Soft cushions. In concert, they yield the Eames soft pad chair. This handsome chair is especially well suited for dining areas,—with its seat-height adjustment and tilt-swivel—it provides unexpected comfort, no matter which member of the family is seated. The soft pad chair evolved from the Eames aluminum group chair line—furniture that was introduced 10 years earlier and originally developed for a private residence being designed by Eero Saarinen and Alexander Girard. With the addition of 2-inch-thick upholstered seat cushions, the soft pad group retains the style of the earlier chairs and enhances long term comfort.

Eames' Soft Pad Chair

EA434
EA435

Product Eames Soft Pad Chair
Available in choice of two leathers, seven fabrics. Polished die-cast aluminum base, frame, and arms; tubular steel column with enamel finish. Seat-height adjustment; tilt-swivel mechanism; five-star base; nylon suspension: glides or casters.

Care Clean soiled leather with a damp, soft cloth and a lather of any mild soap and lukewarm water; wipe clean with a damp cloth and dry with a soft cloth. Do not spot clean leather; clean the entire surface. To clean the fabric, dry clean or spot clean with a solvent cleaner; do not apply any water solutions. To clean polished aluminum, apply a presoftened paste wax—once a month near salt water, every three months in other areas.

If you have questions, please call Herman Miller for the Home, (800) 646 4400.
© 1997 Herman Miller, Inc., Zeeland, Michigan. Printed in U.S.A. H.HC2320-39
™ L.I. herman miller, and Eames are registered trademarks of Herman Miller, Inc.

└┘ **herman miller** for the home

THESE LAYOUTS ARE the inside and outside of a folded insert from a furnishings notebook/catalog. Each folded piece is designed within a strict but sophisticated grid system, allowing the character of the furnishings to visually dominate the layout. An analysis of the layout, shown via the overlay lines, indicates the use of flush left typography. It also reveals an interesting decision to have the visual centerlines of images line up with the upper edges of typographic elements, a strategy that takes advantage of the silhouetted treatment of the furniture imagery.

➤ DESIGN FIRM: BBK STUDIO INC.

more of those guides to place additional elements until another grid line is necessary. Then use one of the new existing elements to indicate where that grid line would be. This strategy can be combined with the reverse engineering strategies mentioned previously as a starting point for a multi-use grid system.

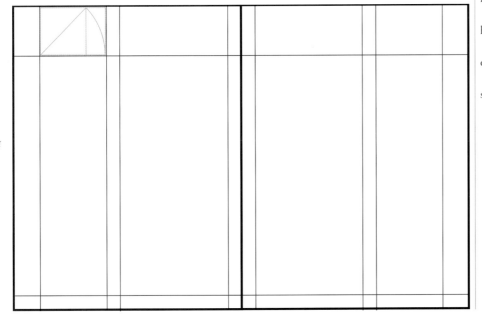

EVEN A STANDARD 8¹/₂" x 11" (21.6cm x 27.9cm) page can be divided according to classic proportions. In this grid the column widths are proportionally five and eight, which are derived from the Fibonacci series. The horizontal grid line was determined by placing the Root-2 Rectangle at the top the outer column and then using its lower edge to indicate a starting point for text and images. As additional grid details became necessary, interpretations of the two formulas could continue to provide guidance.

[4] Finally, a resource designers often use to inspire interesting proportions in all layout efforts, including grid systems, are two classic mathematical formulas: the Fibonacci Series and the Root-2 Rectangle. In the Fibonacci series (1, 1, 2, 3, 5, 8, 13...) each number is the sum of the two that precede it. The Root-2 Rectangle is a rectangle with a ratio of one to the square root of two, which can be derived from a square and its diagonal. Both can be found in man-made designs (either by intention or intuition), as well as in nature. The proportions of classic Greek architecture and the nautilus shell are often cited as examples of these "perfect" proportional formulas. The figures on this page are examples of how to use these formulas in the context of developing a grid. In fact, almost any numerological system can be used to help begin a grid system.

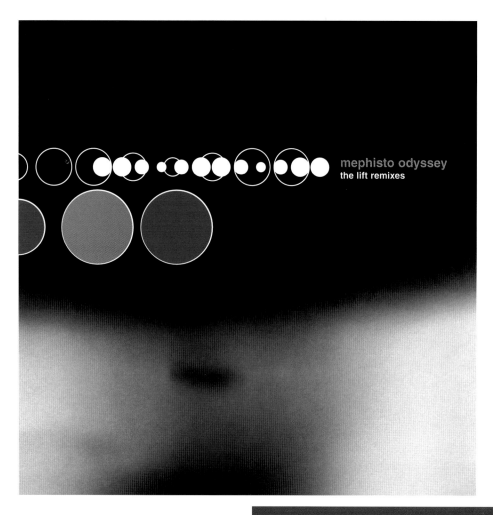

mephisto odyssey
the lift remixes

THESE TWO CD covers are variations on the same original release. Although their designs do not employ a strict grid, a visual system is at work to insure that the designs are related. The horizontal flow of the circles, the reuse of the background imagery and the single typeface in a flush left alignment all contribute to the visual relationships that associate the two designs.

➢ DESIGN FIRM: SEMILIQUID
➢ DESIGNER: MIKE LOHR

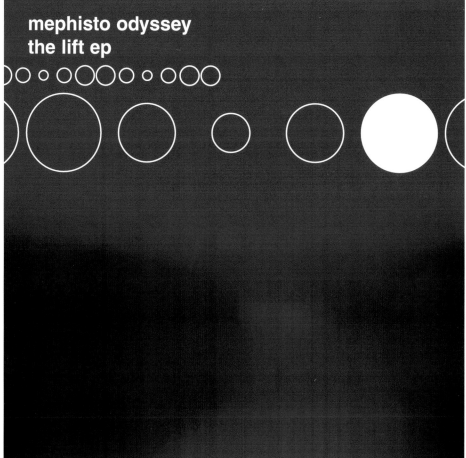

mephisto odyssey
the lift ep

notes to consolidated financial statements

[Financial report text — illegible fine print in columns]

THE GRID SYSTEM *that guides these financial layouts for an annual report utilizes a single column grid with a large white space at the top of the page. Occasionally, the white space is used for headline type, but more often it serves as a contrast to the dense information presented over most of the page.*

➤ DESIGN FIRM: LOUEY/RUBINO DESIGN GROUP INC.
➤ DESIGNERS: ROBERT LOUEY, ASHLEIGH MOSES

Craig Arnold received a B.A. in 1989 from Yale University and is pursuing a doctorate in creative writing at the University of Utah. Arnold, who has served as an editor at *Quarterly West* magazine, received the Amy Lowell Poetry Traveling Scholarship in 1996. His poem "Hot" was featured in *The Best American Poetry 1998*; other work has appeared in *Poetry*, *The Paris Review*, *The Yale Review*, and *The New Republic*.

"A gifted collection of daring writing." —W. S. Merwin

 Arnold **Shells** Yale University Press *New Haven and London*

 Foreword by W. S. Merwin

 Shells Craig Arnold

Craig Arnold's *Shells* is the first book selected for the Yale Series of Younger Poets by the distinguished poet W. S. Merwin. Arnold plays on the idea of the shell as both the dazzling surface of the self and a hard case that wards off the assaults of the world. His poems narrate a dizzying array of amatory and culinary misadventures. "Friendships based on food," Arnold writes, "are rarely stable" —this book is full of wildly unstable and bewitching friendships and other significant relations.

 Yale Series of Younger Poets

ISBN 0-300-07909-5

9 780300 079098
http://www.yale.edu/yup/ Yale

82

THIS BOOK COVER, *in its unfolded form, shows how a grid can guide the placement of elements in a three-dimensional space. Invisible grid lines wrap the book, insuring a cohesive visual experience as a viewer handles the book. Notice the horizontal alignment of the quotation on the back cover, the forward-credit on the front cover and the text on the inside front flap. Another vertical alignment occurs along the grid line between the title type and the red shell at the bottom of the front cover. The exclusive use of Bodoni typefaces adds to the structural elegance of the design.*

➤ JACKET COURTESY OF YALE UNIVERSITY PRESS, DESIGNED BY SONIA SCANLON.

Developing a Grid

There is no magic formula or trade secret to developing a grid, and yet it can be a very illusive design task. My breakthrough in understanding grids came when I sat and watched as another designer sketched and developed a grid for a brochure. Since that opportunity is not always available, here are some other, more readily accessible pointers regarding grid development.

When developing grid systems for repeated use, it is helpful to consider the following strategies:

[1] "Reverse engineer" the grid of a magazine or other publication that you admire. To do this, start with full-sized copies of several of the magazine's layouts. Taking one sheet of tracing paper, use colored pencils to trace the grid lines you think are there. Designate columns, margins, baselines, page number locations, photo locations, etc. Then move that same piece of tracing paper over to another layout. Are there consistent layout decisions from the first layout to the second? If so, note them and then move that same paper over to a third layout and repeat the process. Through this analysis (which you might try with several different publications), you will uncover what the designer was working with as a basic grid and how he or she molded that system into interesting layouts. The insight you gain can be used to guide your own development and use of grids.

[2] Reverse engineering can also be used beginning with a design of your own. If you have the talent to prepare one interesting layout, but cannot quite imagine how to expand it into a grid, then work on one layout to about 75 percent completion. Analyze it for its placement of basic elements, then try and apply that analysis to a second layout, and so on. Work forward and backward through the layouts, adjusting the grid based on what does and does not work, until you arrive at a final system. By extrapolating from one layout, and then adjusting as various strengths and weaknesses of the system are revealed, you can design a grid based on your own intuition.

[3] When it comes to creating an internal or single application grid, a third strategy is to simply start with one element and let the grid develop from there. For instance, placing the headline type will provide a left and right vertical grid line as well as a horizontal guide. Use one or

More (About) White Space!

White space is an essential element in design, and that includes layouts developed via grids. A grid system should designate both the areas to be filled as well as the areas that are to be left alone. By including a large margin of white space in the basic plan, designers not only provide layouts with a chance to look well-planned and sophisticated, but they also have an area in reserve as a natural outlet for exceptions to the grid's rules. In these instances the white space can be forfeited to accommodate such elements as an extra large image or additional type. Occasionally infringing on the white space may satisfy a content need, and also offer a rhythmic shift, providing some useful visual tension.

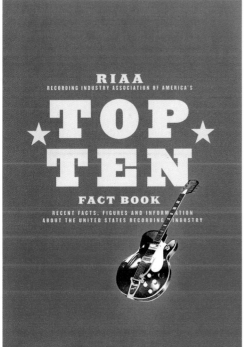

TOP ALBUMS OF 1996

14 MILLION
Alanis Morissette, "Jagged Little Pill," Maverick/Warner Bros. Records

8 MILLION
The Beatles, "Anthology, Volume 1," Capitol Records

7 MILLION
Celine Dion, "Falling Into You," Epic Records
Soundtrack, "Waiting to Exhale," Arista Records
Smashing Pumpkins, "Mellon Collie and The Infinite Sadness," Virgin Records
2Pac, "All Eyez On Me," Death Row/Interscope Records

5 MILLION
Fugees, "The Score," Ruffhouse/Columbia Records
No Doubt, "Tragic Kingdom," Trauma/Interscope Records

4 MILLION
Garth Brooks, "Fresh Horses," Capitol Nashville
Shania Twain, "The Woman In Me," Mercury Nashville
Oasis, "What's The Story Morning Glory," Epic Records

3 MILLION
Toni Braxton, "Secrets," LaFace/Arista Records
Tracy Chapman, "New Beginning," Elektra Records
Alan Jackson, "Greatest Hits Collection," Arista Records
Metallica, "Load," Elektra Records
R. Kelly, "R. Kelly," Jive Records
Mariah Carey, "Daydream," Columbia Records
Hootie & The Blowfish, "Cracked Rear View," Atlantic Records
TLC, "CrazySexyCool," LaFace/Arista Records

21

WHO SAID INFORMATION *design couldn't be fun? This fact book for the music industry is "jazzed" up with bright colors and innovative presentation decisions, such as the spherical pie chart, particularly appropriate because the statistics refer to the global marketplace.*

> FIRM: RECORDING INDUSTRY ASSOCIATION OF AMERICA
> CREATIVE DIRECTOR/DESIGNER: NEAL ASHBY

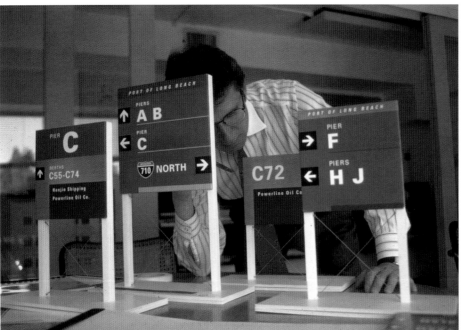

ENVIRONMENTAL GRAPHIC DESIGN

includes several steps and processes that are not typical in print design. During a design phase, scale models are produced and analyzed. For fabrication purposes, mechanical drawings that indicate the grid for fabricating all similar signs are produced. In these images from the Port of Long Beach signage program, you can see examples of these steps, as well as the final result: Clear signage that stands out in the busy industrial landscape.

➤ DESIGN FIRM: HUNT DESIGN ASSOCIATES
➤ DESIGNERS: JOHN TEMPLE, DINNIS LEE

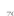

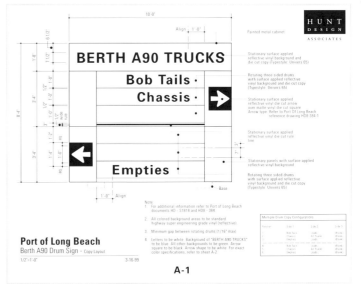

Port of Long Beach
Berth A90 Drum Sign - Copy Layout

1/2"=1'-0" 3-16-99

A-1

[2] A second type of grid is one that evolves during the design process for a one-time application. This type of grid provides the designer with an underlying logic for layout decisions. A typical application of this sort of grid is often a stationery system, although almost all designs, including posters and book covers, are often laid out using a sort of "internal" grid. With this particular grid strategy, once a design has even one element placed into the layout, the location of future elements is implied through that—and each subsequent—decision.

[3] The most strictly structured use of grid systems is within the field known as information design. Within this subcategory of graphics, which includes helping people understand specific technical, monetary, geographic and time-based information, designers use grids to assist them in making vital information as clear and as easy-to-access as possible. One common example of a grid being used to convey information is the chart. In the hands of a graphic designer, even the most basic presentation of information can become an example of visual excellence and clear communication.

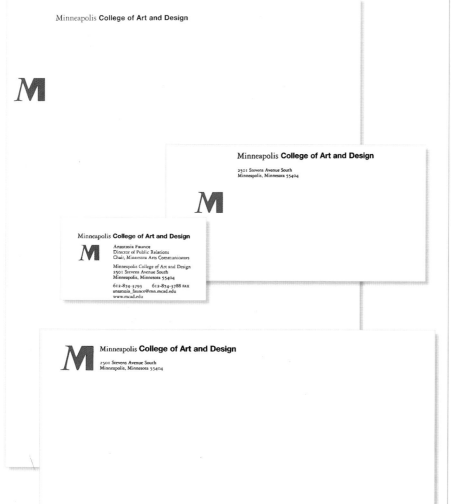

THIS STATIONERY PACKAGE *is an excellent example of how one initial decision can inform all the decisions that come after it. The result is a consistent and logical identity program. The logo is a hybrid of two M letterforms, one Old Style and one modern. The implication is a nice one—the school approaches its mission from both traditional and contemporary perspectives. Following the lead of the logotype, the name of the school is set in the same two faces: Old Style on the left and modern on the right. On the business card, the location of the change in typeface is used to create a vertical grid line that helps locate the support type. On the letterhead, envelope and mailing label the large areas of white space allow for a different set-up with the support type flush left of the name of the school.*

DESIGN: MINNEAPOLIS COLLEGE OF ART AND DESIGN

The Reason for Grid Systems

There are a variety of reasons to develop a layout guide, or grid, as well as a few different ways of developing grid systems.

[1] Perhaps the most common reason to develop a grid is a necessity for a reusable system for multipage and/or multi-issue publications. Imagine that every month, the designers at a magazine had to start from scratch, making all new design decisions for each new article in each new issue! Magazines, and their relentless deadlines, are a perfect example of how grids can streamline the design process. The use of a grid system helps make the most of the effort that goes into initial design decisions by guiding their implementation many times over. In addition to providing magazines, newsletters, brochures, booklets and newspapers with reliable design guidance page to page and issue to issue, grids also foster a consistent design "look"—an essential when cultivating a devoted readership.

A STRICT SET of design guidelines for the packaging of Michael Graves products for Target stores supports the communication of several important points: 1) The consistency helps designate and identify the Michael Graves brand, 2) the set of nonchanging elements (most notably color, typographic treatment and white space—or in this case, blue space) allows the most important element of the packaging—the item being sold—to stand out, and 3) the consistency works to mitigate the differences between different package sizes and structures—again, allowing the form or image of the item to clearly stand out in the busy retail atmosphere.

➤ DESIGN FIRM: DESIGN GUYS, INC.
➤ CREATIVE DIRECTOR: STEVE SIKORA
➤ DESIGNERS: GARY PATCH (KITCHEN TIMER AND GARDEN TOOLS); STEVE SIKORA, SCOTT THARES, TOM RIDDLE (TEA KETTLE AND TOASTER)

What Rules

Designs for projects such as books, brochures, magazines and newspapers have certain elements in common: columns for text, areas for illustrations and photographs, headlines, page numbers, margin notes, etc. To successfully juggle all this information, designers often create an underlying set of placement guidelines, called a grid. Although in the final product, the grid lines are invisible, their effect upon a design is not: Grids are essential for creating visual consistency in projects that move across multiple pages, panels or screens.

While the very term "grid" may conjure notions of rigidity and unbendable rules, in the context of design it is more productive to think of a grid as an extremely helpful starting point. A well-planned grid system allows for rule following, rule bending and even some rule breaking. Grids don't limit design creativity; they give a design a solid foundation from which to grow and flourish.

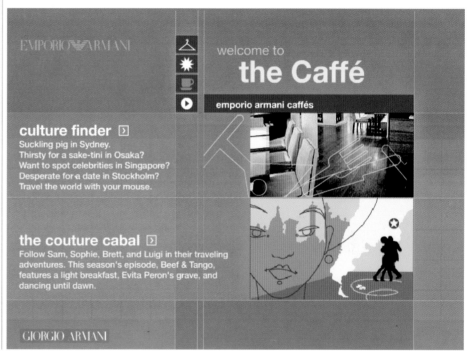

IN ONLINE DESIGN, grids are utilized to visually organize the information and also to divide the screen into technically manageable pieces. In this design there are intentionally visible traces of the grid lines. The thin lines not only refer to the site's structure, but also provide contrast against the massive orange and photographic shapes.

➤ DESIGN FIRM: RAZORFISH
➤ CREATIVE DIRECTOR: DAVID WARNER
➤ DESIGNERS: REBECCA BRODY, KENDALL THOMAS, TRAVIS ROGERS

["Environments are invisible.

Their ground rules,

pervasive structure and overall

patterns elude easy perceptions."]

marshall McLUHAN and

quentin FIORE

The Medium Is the Massage

S

TOP TEN W
(F

No big surprises. Nearly ha
dominated by two countrie
United States still reigns su
But consider the enormous
corded music universe. The
places where copyright pro
Eastern Europe, China, Indi
former Soviet Union and M

" Their album, *The Score*, sold over
...llion last year and their single
Fu-Gee-La went Gold

1/50 *Life.* Child mortality in 1960 was 250 deaths pe
oping world. Today it is 100

grid
SYSTEMS

Invisible except to the trained eye, grid systems are a subtle but vital part of the

design process. Not only do grids provide publications and other media with structure,

but also a rhythm to which they can dance.

.05

CHAPTER

intro

1900's

As official photographer on the 1899 E.H. Harriman Expedition to Alaska, Edward S. Curtis began to realize the valuable role photography could play in recording the lives and customs of Native Americans, whose traditional way of life had been nearly obliterated by the advance of the white settlers. The experience caused Curtis to dedicate his life to documenting "every phase of life among all tribes yet in primitive condition." The subject of *Bear's Belly, Arikara* was born in 1847 in North Dakota. At the age of nineteen, the elders in his tribe told him that the surest way to gain honors was to join General Custer's scouts at Fort Abraham Lincoln in the Black Hills country. Though he had no experience in war, he promptly joined the group. He later became a member of the Bears, a medicine fraternity. The standards to which documentary photographs are held today were not yet fully established when Curtis was working, and the artist used techniques learned during his early Pictorialist days to romanticize the truth. It is possible that the costume Bear's Belly wears was a prop and may have been worn by other subjects as well. Despite such

Edward Curtis
Bear's Belly, Arikara, 1908
Photogravure, 15 5/8 x 11 3/4 in.
(39.7 x 29.8 cm)
Collection of Christopher Cardoza

◄ PREVIOUS Legal Information © 1999 Intel Corporation NEXT ►

● MOVE MOUSE HERE TO SHOW TIMELINE

1900 - 1909 1910's 1920's 1930's 1940's 1950's 1960's 1970's 1980's 1990's

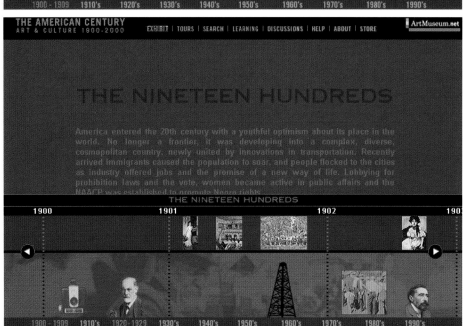

TO ACCOMPANY "THE American Century" exhibit at the Whitney Museum of American Art, Razorfish designed a site that presents two hundred works from the exhibition, along with materials that link the art with themes, events and social issues of the period. Structure and organization are critical aspects of the design because the depth of the information presented requires the user to move not only horizontally along the timeline, but up and down between the two timelines (art and culture) and "into" the site to further understand a particular work. Grid systems allow the in-depth screens, such as this one with an Edward Curtis photograph, to contain links to auxiliary media, an abbreviated version of the timeline, bookmarks to collect one's favorites as well as substantial narrative information. This site truly lives up to the promise of the Internet as a catalyst of the information age.

➤ DESIGN FIRM: RAZORFISH
➤ CREATIVE DIRECTORS: DAVID WARNER,
 THOMAS MUELLER
➤ DESIGNER: KENDALL THOMAS

73

Constrained Thinking: From Network to Membra[ne]

Paul Harris

From the outset, electronic textuality has been promoted through a kind of academic version of a hack that "information wants to be free" and computers will democratize the world, proponents have celebra bursting out of the strictures imposed by print, and theorized its role in undermining hierarchies in large. This ethos has been grounded in an epistemology which has remained relatively implicit and the underlying sense in hypertext theory that electronic textuality is somehow more "natural," more inher perceived fit between mind and machine is, in turn, based on a tacit assuumption: the brain and elect along the lines of linked networks. To cite just one example, George Landow has urged that "in contra of access produced by means of managing information based on print...an information medium is needed mind works" (7). Landow, informed by Vannevar Bush's work, sees computers as "machines that work acco machines that capture and create the anarchic brilliance of the human imagination" (10).

The model of mind at play in electronic textuality emerges at a curious disciplinary nexus. Both the by Landow and others, and certain strands of cognitive and computer science have contributed to a de mind. For all their differences, post-structuralism and some strands of cognitive science mark a shif of causal reasoning and analysis to an image of thought as a "parallel, distributed" process of non-l syntheses. From the standpoint of the epistemology proposed in theories of electronic textuality, the rational mind are displaced by the non-linear articulations of the reticulated brain. And electronic brain to speak its mind, enabling the thoughts that take shape in cerebral neural networks to find ex "anarchic brilliance of the human imagination" is unleashed in the acentered labyrinth of the world w theory, its conceptual models cast in the image of linked lexia, has basically (if unwittingly) taken model of the brain. In contemporary philosophy of mind terminology, this is a functionalist model; it depends on its functional organization. Such functional organization is like a software, which could other words, if the brain's functional organization can be simulated with algorithms, then computers functionalist view also subtends extrapolations like Hans Moravec's scenario of downloading one's bra "digital immortality."

The strongest response to the functionalist view comes from neurobiologists who insist that detailed wetware severely limits any analogy to be drawn between digital computers and human brains. >---[10]

THE ELECTRONIC BOOK *Review is an online publication "promoting print/screen transformations and weaving new modes of critical writing into the Web." Unlike printed magazine pages, screen pages can scroll to accommodate the complete text of a manuscript. The table of contents and article pictured here both continue past these cropped screen shots and feature complete texts on a single screen without sacrificing legibility. The metaphor of weaving stated on the cover page is visually represented on subsequent screens through patches of text that layer to create new patterns, in itself another metaphor for the interconnected relationship that reader, editor, designer and author share in this digital publication.*

➤ DESIGN: ANNE BURDICK: THE OFFICES OF
ANNE BURDICK

▶▶ ON-SCREEN CONTRAST & READABILITY: The projected light of the computer screen is both a blessing and a curse. While it allows for bright, vibrant color to be part of the design, projected light combined with screen resolution can create readability concerns. One tactic for assessing the readability of a design is to reset the monitor and review a project in black and white. This allows the designer to check that the proper contrast and size have been assigned to the typographic elements.

▶▶ SOUND & MOTION: Two increasingly indispensable elements of Web design are features that were not previously part of a typical graphic designer's skill set: sound and motion. Sound can enhance the recognition of a visual symbol (as with the THX "whine" at the start of a movie), as well as add sensory depth to an online experience. As technology and bandwidth expand, the use of online motion-based graphics becomes more common for everything from small dancing icons to full-screen animated introductions. Graphic techniques that were, until recently, confined to movie titles or broadcast graphics, now flourish on the Web. Online design has opened up new opportunities and placed graphic design at the crossroads of "convergent media," requiring designers to expand into new areas of expertise.

Online Design Considerations

While many of the design principles that have guided graphic design for decades apply to online design, there are additional challenges when designing in this new environment. It's best to fully acquaint yourself with online technology before you begin, but for starters, here's a partial list of online design concerns.

▶▶ SITE ARCHITECTURE: Although several book metaphors (pages, bookmarks) are used to describe the Web, the differences between the two media are significant. In a book, the pages can be turned in two directions: forward or back. Within the Web, users can go forward, backward, in, out and all around...even jumping from one site to another. The logic of a site and how it works—its architecture—is key to its success.

▶▶ BROWSER COMPATIBILITY: Unlike print, Web designs can change depending on the circumstances of their viewing. Browsers, browser settings and the capabilities of the viewer's computer can all affect the appearance and functionality of the Web site. Experienced designers know to check and recheck their designs under a

variety of circumstances for the greatest chance that the Web site will not only function, but will also look good, under a variety of circumstances.

▶▶ HTML: Behind every page on the Web is the source code (which can be viewed by choosing "view" and "source" in the browser). This code, written in a scripting language called HTML (hypertext mark-up language) generates everything the viewer sees on the Web page. It's a bit strange to think that to draw a simple line, code needs to be written, but that's the way the World Wide Web works. Working with a programmer to take a Web site beyond the designer's basic understanding of HTML is often the strategy used by designers who think it unwise to get bogged down with "back of the house" considerations.

▶▶ WYSIWYG EDITORS: Programs such as GoLive and DreamWeaver allow designers to convert designs done in familiar layout programs (such as Pagemaker and Quark) to Web pages. They take the page design as your see it on your computer screen and automatically generate the HTML necessary to make the design work as a Web site (which is why they are called "What You See is What You Get"—WYSIWYG editors—pronounced "wizzy-wig"!) Although this is a convenient way to generate a simple Web site, or to prototype a more complex one, any Web site that utilizes a database or other e-commerce features will require true programming expertise.

[3] Change the order in which you are sketching the components of your design. If you always start your sketch the same way, all the sketches will be somewhat the same. Pushing different elements to the beginning of the sketch process will help uncover new possibilities.

[4] Change the position and size of the elements on the page. It seems that, unintentionally, designers will often sketch one particular element in the same place and/or in the same size in each

ERASURE IN MY ARMS

VINCE CLARKE and ANDY BELL

Maxi-Single

9 43857-0

THE DISTORTED ANGLE of the photograph contrasts the straight lines of the typographic treatment of this CD cover. The alignment of the band name with the subject's head and the use of red in both the photograph and the title type help hold the elements of the design firmly together.

➤ DESIGN FIRM: GIG DESIGN
➤ DESIGN: LARIMIE GARCIA FOR GIG DESIGN

sketch (over and over and over!). Forcing an element into a different role on the page may open up a whole new avenue for investigation. For instance, who ever said a headline had to be large and at the top of the page?

[5] For at least a few of your sketches, don't include an element that you assumed had to be part of the design. For instance, what would a poster about "time" look like without a clock? How would you visually represent "winter" without any images of snow or ice? Presented with such limitations, you will undoubtedly come up with some ideas that are more innovative than if you had settled for the expected.

[6] Break up your sketch process. If you can take several breaks from sketching, then each time you return to the project, you will have a fresh eye and new energy for new ideas. When you return to your sketches, examine what you have done and then ask yourself what you haven't yet investigated (reviewing this list of rules will help answer that question). Use your answer to move into unexplored territory.

[7] Never, ever, ever edit yourself while sketching. If you think it, draw it. No exceptions. There is no such thing as a bad idea. Perhaps that fleeting thought that you attempt to push out of your brain won't be the idea that you ultimately use, but it could very well lead to the idea that is chosen. You won't know until you put it down on paper!

MAKING SURE
YOU GET THE PICTURE

ANTEC Network Technologies

NO INSULT TO broadband technologies intended...but the stuff isn't very exciting to look at! Nevertheless, if that's what your client is selling, then it's up to you to successfully integrate the information into a strong design. In this brochure it's the high-contrast aspect of the designs, the bright colors and strong graphic shapes that read first and strongest in the design hierarchy. The photography is, wisely, subordinate in the overall visual scheme of the layouts.

➣ DESIGN FIRM: WAGES DESIGN
➣ ART DIRECTOR: BOB WAGES
➣ DESIGNER: MATT TAYLOR

69

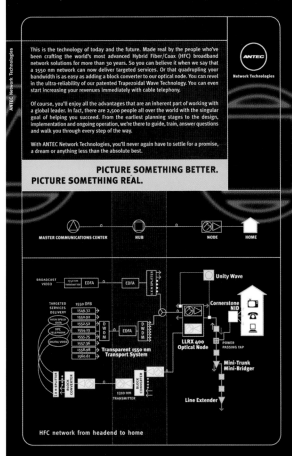

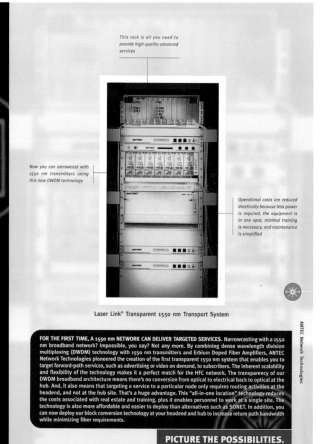

7 Sketching Rules

Sketching is part of the ideation phase. The sketch process can and should serve two purposes: First, it puts onto paper ideas that were already in your head, and second, it helps produce new ideas. The latter is the more elusive of the two. Over the years, as I have analyzed my own sketching process and those of students, I have come up with the following list of "sketching rules" to help make the ideation phase a time for generating new and unexpected ideas for your design:

[1] Use a very soft pencil with a thick lead to sketch your ideas. A soft (and yes, messy) lead will prevent you from treating your ideation sketches like final designs. Using such an informal tool will help keep your process unencumbered by nit-picking and preciousness. It will keep the ideation process fresh and fast.

[2] Don't try and fit your ideas into rows of predrawn squares. Some ideas are meant to be drawn big while others are meant to be drawn small...some in the center of the page and others in the margin. Just let the ideas flow. After you generate your initial, perhaps somewhat random thoughts, you can create a clean copy and organize the sketches into a presentation for the client.

THE THREE MAIN *elements of these layouts—the western type, the Chinese type and the ink drawings—have unique relationships to one another. The western type and the Chinese type are both informational, but the former is more structured. The Chinese type and the ink drawings share their organic characteristics. The western type and the ink drawings play off each other to provide contrast to the composition. The color red for both the fine lines and the calligraphic blocks further interweaves the components in this booklet about the universe.*

➤ DESIGN FIRM: ERIC GRAYBILL DESIGN

PAN GU AND THE
CREATION OF THE UNIVERSE

The forces of change are at work.

Organizations are redesigning, people are searching, work styles are migrating.

Experimentation is flourishing, technology is advancing.

Change is endless. Time is precious.

To sustain value, space must be dynamic – full of flexibility.

The right space helps you harness change.

Increase its speed.

Minimize its disruption.

Contain its costs.

Make it your ally.

THE FUTURE IS UNPREDICTABLE

THE THEME OF *this capabilities brochure for a furniture company explains how space is used for business, culture and technology. The structural black-and-white shapes, along with the simple text treatment and aligned title type represent the organized ideal of any office, while the color collages represent the chaotic reality of the workplace. Through the use of color (black in particular) and overall shapes that are complementary, the contrasting aspects of each composition work with, not against, one another.*

➤ DESIGN FIRM: BBK STUDIO, INC.

67

Human energies, experiences, and emotions fuel performance.

Is your workplace keeping pace with your workforce?

Is your population becoming more diverse?

Are your people in constant motion?

Do they struggle to balance work time with personal time?

Are you creating a new work culture?

What message does your workplace send about the value you place on people?

Does it contribute to personal comfort and health?

Does it exhilarate? Does it satisfy?

Does it delight the people it serves?

PEOPLE ARE VITAL

Steelcase and our dealers collaborate with your workplace team.

Exploring the ways your people work, and opportunities to leverage space for better business results.

Using an innovative methodology and tools to help define criteria for a high-performance workplace.

Supporting new planning concepts and forward-thinking furniture applications – to enhance both group and individual work.

Providing order fulfillment and installation services, including employee orientation activities.

Managing moves, changes, and additions to your environment over time.

Measuring outcomes against workplace performance targets at every step along the way.

SERVICE AT EVERY STAGE

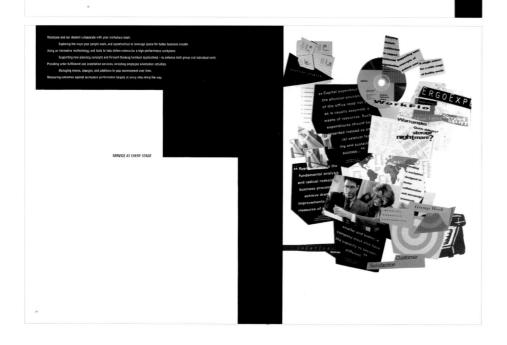

copINg *and* growINg

A mericans in the 20th century have seen much triumph, brilliance and ingenuity; they have also lived through periods of profound loss and tragedy: war, economic recession and depression, political unrest, natural disasters, the threat of nuclear annihilation, and the decline of once-great urban centers. These difficult times often affect young people deeply. The arts offer them an important outlet for coping with the emotional effects of public and personal crises. The use of the arts to help young people in jeopardy is evident throughout the century — from the special federal and local programs created to combat the devastating effects of the Great Depression, to initiatives designed by teachers to strengthen the resolve and allay the fears of young people in times of war, to more recent efforts to get teenagers at risk off the streets and out of trouble.

The arts provide a safe container for every person or every culture or every group to express things about coming into being as an adult, dealing with hardship, dealing with a sense of beauty. No other activity provides us with that. [The arts and humanities] allow us culturally, individually to say things we might never get to do.

Carlos Uribe, *Director of Programs, Center for Contemporary Arts of Santa Fe Teen Project*

Case study: *Rise **and** Shine Productions*

Founded in 1985 by a diverse, multi-ethnic team of artists and educators, Rheedlen's Rise & Shine Productions is a Harlem-based social services organization dedicated to empowering young people and their communities through the creative use of language, the arts, and media technologies. In after-school, in-school, and community workshops, the teachers and artists involved in Rise & Shine Productions help students to develop basic skills in the language and visual arts, as well as in scriptwriting, video, and other electronic media. The program creates a safe environment for young people throughout New York City to direct, write, and star in videos that explore the problems and issues that are central to their lives. The program's major goal is to encourage media literacy in young people in order to help them to think for themselves and to question and counteract negative, stereotypical media images that perpetuate self-destructive behavior, such as truancy, teenage pregnancy, alcoholism, and drug abuse.

24 25

THE DESIGN OF this exhibition catalog creates a sense that it is both old and new. Inasmuch as the content is the writing and artistic work of high school students from the past seventy-five years, that simultaneity seems appropriate. This timeless impression is the result of using both contemporary and classic motifs. The thin rules of varying weights that compose the rectangles are a classic convention, but their overlapped use is very contemporary. The use of initial caps (as with the A under the word "coping") is quite old-fashioned, while the use of the Mrs. Eaves typeface, a contemporary face that was designed with Baskerville in mind, spans several centuries. In the end, the mixed-case typography and contemporary imagery seal this design's place firmly in the here and now.

➤ DESIGN FIRM: RALPH APPELBAUM ASSOCIATES, INC.
➤ AUTHOR: MAURICE BERGER
➤ DESIGN: MATTEO FEDERICO BOLOGNA

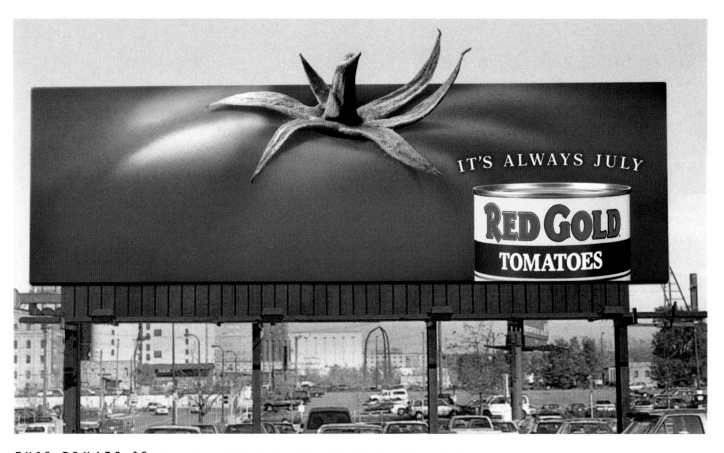

IT'S ALWAYS JULY

RED GOLD
TOMATOES

THIS TOMATO IS so huge and ripe and juicy that it wouldn't even fit on the billboard! At least that's the thinking implied through the tight cropping of the image. The visual impact of the tomato is much greater than if the image had fit conveniently into the rectangular border. The decision to have the stem breaking out of the rectangle 1) further emphasizes the bursting quality of the image, 2) creates contrast by placing an organic shape next to straight lines and 3) helps identify the abstracted red shape as, indeed, a tomato.

➤ DESIGN FIRM: YOUNG & LARAMORE ADVERTISING
➤ EXECUTIVE CREATIVE DIRECTOR: JEFF LARAMORE
➤ ART DIRECTOR: PAM KELLIHER
➤ PHOTOGRAPHER: TOD MARTENS
➤ DIGITAL ILLUSTRATION: JEFF DURHAM
➤ WRITER: SCOTT MONTGOMERY

QUESTIONS WORTH ASKING

What Tools Do I Have to Work With?

Of course you have type, photography, illustrations, background and graphic elements to work with when developing a layout. But the real question is how you use these tools. For instance, when set in body copy, typefaces with different densities create different light or dark areas of texture. These textures are also referred to as the color of the type and can be used to create subtle visual tension within a layout. Another useful tool is white space, which can provide areas of quiet on the page. The possibilities are actually quite limitless. An excellent exercise to inspire creative use of layout tools is to think of opposites that are appropriate to your message and then develop ways of "acting out" those contrasts graphically. Some inspiring ideas might result from thinking about:

❖ **perfect** / *imperfect* ❖ **moving** / still

❖ **whole** / cropped ❖ **primitive** / contemporary

❖ **steady** / shaky ❖ **strict** / informal

❖ **focused** / blurred ❖ **single** / multiples

❖ **staying** / leaving

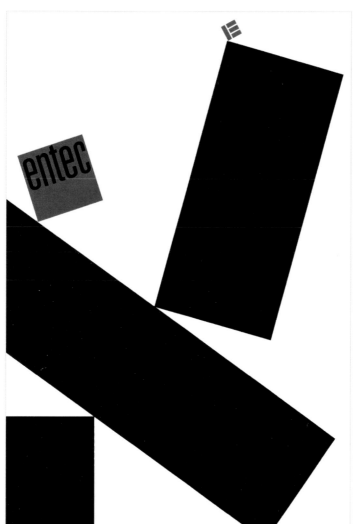

THIS BROCHURE COVER *is an excellent example of how composition can create visual tension. The black rectangles and red squares in this composition are so perfectly perched upon one another that it seems that at any moment, the layout itself might come tumbling down!*

➤ DESIGN FIRM: MAUK DESIGN
➤ ART DIRECTOR/DESIGNER: MITCHELL MAUK
➤ WRITERS: MITCHELL MAUK, DAMIEN MARTIN,
 RAYMOND BURNHAM JR.

frank
g e h r y

When I began to find my style there simply wasn't much of a support system for anyone trying something different. There were not a lot of people I could talk to. The established firms guarded their turf and considered the few of us who were trying to innovate as interlopers a threat to their sense of security.

I guess I am still struggling with my own insecurities, despite all the recent publicity my work has had. Every time I grapple with a design problem I will always feel as vulnerable as I ever did, that is what makes me self-centered, like most creators.

IN THIS LAYOUT, *it is the thin diagonal line that creates the visual dynamic, but only because all other elements on the page are not diagonal. It is the noticeable difference between the line and the other elements that creates the interest and tension.*

➤ DESIGN FIRM: ERIC GRAYBILL DESIGN

[5] IMPLIED SPACE: This is one of the most dramatic devices in graphic design. In fact, dramatic production is the easiest way to describe this principle: Think of the offstage knock at the door or the expression on an actor's face when he or she sees something beyond the screen. In both these instances, the actual space of the movie screen or theatrical stage is expanded by implication. In graphic design, the implied space is the area the designer references beyond the actual page. The use of scale (so that an object is so large that it bleeds off the edge of a page) and/or the use of repetition (so that a sequence of images or letters "marches" off the edge of the page) are two common strategies for achieving implied space.

In addition to helping establish a visual hierarchy, the strategies above contribute to the visual tension in a layout. Visual tension does not mean "unresolved"; it just means that the layout's elements are in a dynamic and noticeable dialogue with one another. Without an appropriate amount of unpredictability or excitement within a layout, viewers may not notice a design.

Eleanor Antin

WHO IS POINTING a gun at that ballerina? We may never know. But one thing is certain—this catalog cover design for a performance artist is an exquisite example of implied space. The drama unfolding between the two figures extends, at least intellectually, far beyond the actual edges of the design.

➤ DESIGN FIRM: LAUSTEN & COSSUTTA DESIGN

[3] SEQUENCING OR VISUAL RHYTHM: Imagine a movie without any close-ups or long shots, or a song in which all the notes were held for the same duration—it would be painfully uninteresting and artificial. The world around us is interesting because of rhythm.

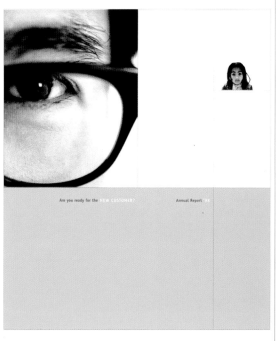

Are you ready for the NEW CUSTOMER? Annual Report

AS THIS ANNUAL report cover clearly demonstrates through its use of photography, scale can create the illusion of depth, making it seem as though elements on the same page are a great distance from one another.

➤ DESIGN FIRM: KIM BAER DESIGN ASSOCIATES

QUESTIONS WORTH ASKING
What Is White Space?

White space can be thought of in many ways, but it should not be thought of as empty or unused. Open space in a layout is a crucial layout tool. It can direct our gaze toward what *is* there by providing a quiet zone around an important element. It can add a sense of sophisticated restraint to a design (think of the difference between a package from Tiffany's and a bottle of Jolt Cola!). White—or open—space is invaluable to the idea of visual balance, either symmetrical or asymmetrical. Even certain letters of the alphabet would be unreadable without their white spaces. One can imagine white space to be the visual equivalent of a private refuge—a necessary place to clear your mind and contemplate for at least a few minutes each day.

The ocean's waves, a heartbeat, even the urban sounds of a city pulse with variety; so should your designs. Visual rhythm, or sequencing, can be achieved through changes in the pace of a design via:

▶▶▶Setting up a regular system of elements and then interrupting that system

▶▶▶Opting for a surprise change in scale

▶▶▶Moving an element out of its expected position

▶▶▶Eliminating an expected element

▶▶▶Changing the quantity of a particular item, such as the amount of type typically placed on a given page.

[4] DEPTH: Graphic design typically occurs on a flat surface. Nevertheless, a common feature of many designs is the implication of a three-dimensional depth to the page. Three ways to provide a design with depth are with scale, layering and foreground/background relationships. Color and contrast have a part to play in the creation of visual depth as well, as the elements with the highest contrast/brightest color will appear to move forward, while those lower in contrast will appear to be farther back in the composition.

The Pinball Theory of Dynamic Layout

Long before video games took over, arcades were filled with pinball machines. The point of pinball was to activate the machine's two flippers in order to whack the ball back into the live area of the machine—where it could bounce around and touch on as many scoring surfaces as possible. The longer the ball was in play, the more points would be scored. Think of your layout in terms of pinball, and the ability of that layout to keep the eye on the playing surface, touching upon all elements within the layout. This means a dynamic relationship needs to exist between the elements—not all lined up on one side (the viewer's eye will slide down), not all at the top (the eye will drop off at the bottom). And as with pinball, just a slight tap of the eye with a small but distinctive element (a page number, perhaps?) can keep the eye in play, and the communication score going higher and higher!

NOTICE HOW YOUR eye travels through this design? The layout is an excellent example of the pinball theory because the relationships between the elements (especially the three red items as well as the highest contrast word on the page: "lounge") keeps the eye focused yet always moving on the design, offering the viewer multiple chances to receive all the information offered.

➤ FIRM: RECORDING INDUSTRY ASSOCIATION OF AMERICA
➤ CREATIVE DIRECTOR/DESIGNER: NEAL ASHBY

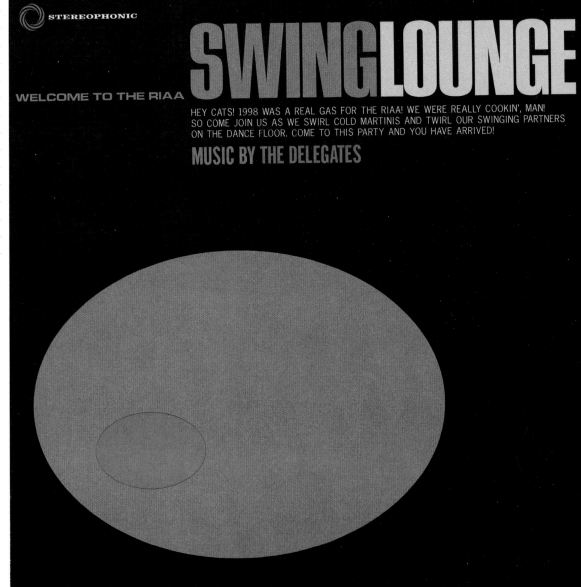

gr. '95

Rewind

Fastforward

45 YEARS AND BEYOND @
THE RECORDING INDUSTRY ASSOCIATION OF AMERICA

ALTHOUGH THE CONTENT *in this Recording Industry Association of America annual report includes dry financial information, the feel of the music business is communicated through "edgy" treatment. (See page 28 for more of this annual report's layout.)*

➤ FIRM: RECORDING INDUSTRY ASSOCIATION OF AMERICA
➤ CREATIVE DIRECTOR/DESIGNER: NEAL ASHBY

◄◄

CONSUMER

PROFILE

24

THE 1995 CONSUMER PROFILE GIVES THE MUSIC INDUSTRY
VITAL DEMOGRAPHIC INFORMATION ABOUT THE PEOPLE WHO ARE BUYING
SOUND RECORDINGS IN THE UNITED STATES. YOU MIGHT HAVE GUESSED THAT ROCK AND COUNTRY
ARE OUR FAVORITE KINDS OF MUSIC, THAT TEENS
DOMINATE THE BUYING MARKET AND THAT CD'S ARE OUR FAVORITE FORMAT.
BUT DID YOU REALISE THAT BABY BOOMERS ARE THE SECOND
LARGEST GROUP OF MUSIC PURCHASERS? THE FOLLOWING CONSUMER PROFILE BREAKOUTS WILL
GIVE YOU MORE DETAIL ON THESE AND OTHER
DEMOGRAPHIC STATISTICS FROM 1995.

An interesting note within our consumer profile regards the high importance people place on music in their everyday lives. When we asked all consumers - meaning people who did and did not buy music - we found that on a scale of one to 10, music plays a significant role for them with a mean score of 6.96. The ranking increased to a very healthy 7.86 when scores were tabulated only from the people who bought music. Americans clearly love and depend on their music of choice, which is especially true for Classical music fans, who were more likely than buyers of any other music genre to give Classical a per- fect "10" on their scale of importance.

The consumer demographic information presented throughout this report was compiled by Chilton Research Services under the guidance of the RIAA's Market Research Committee. A total of 3,065 music buyers (313 each month) were interviewed over the phone to determine their past-month purchases of prerecorded music. Data from the monthly survey is tabulated quarterly, weighted by age and sex, and then projected to reflect the U.S. population age 10-and-over. The reliability of the data is ± 2.0 percent at a 95 percent confi- dence level.

➤➤

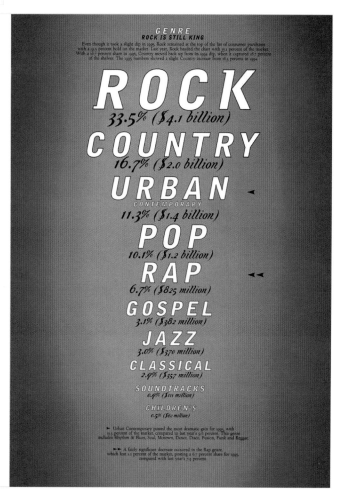

GENRE
ROCK IS STILL KING

Even though it took a slight dip in 1995, Rock remained at the top of the list of consumer purchases with a 33.5 percent hold on the market. Last year, Rock headed the chart with 35.1 percent of the market. With a 16.7 percent share in 1995, Country moved back up from its 1994 dip, when it captured 16.7 percent of the shelves. The 1995 numbers showed a slight Country increase from 16.3 percent in 1994.

ROCK
33.5% ($4.1 billion)

COUNTRY
16.7% ($2.0 billion)

URBAN
CONTEMPORARY
11.3% ($1.4 billion)

POP
10.1% ($1.2 billion)

RAP
6.7% ($825 million)

GOSPEL
3.1% ($382 million)

JAZZ
3.0% ($370 million)

CLASSICAL
2.9% ($357 million)

SOUNDTRACKS
0.9% ($111 million)

CHILDREN'S
0.5% ($62 million)

► Urban Contemporary posted the most dramatic gain for 1995, with 11.3 percent of the market, compared to last year's 9.6 percent. This genre includes Rhythm & Blues, Soul, Motown, Dance, Disco, Fusion, Funk and Reggae.

►► A fairly significant decrease occurred in the Rap genre, which lost 1.1 percent of the market, posting a 6.7 percent share for 1995, compared with last year's 7.9 percent.

More dreams coming true

building
quality and
value

Building *affordable* homes is far more than a philosophy – it's our strategic edge. We're a low-price leader in every one of our markets, offering great value to first-time and first move-up buyers. That enables us to build volume and market share, which creates even more *cost savings* that we can pass back to our customers. It means that more young families who never thought they could afford a home can fulfill their *dreams* with Kaufman and Broad.

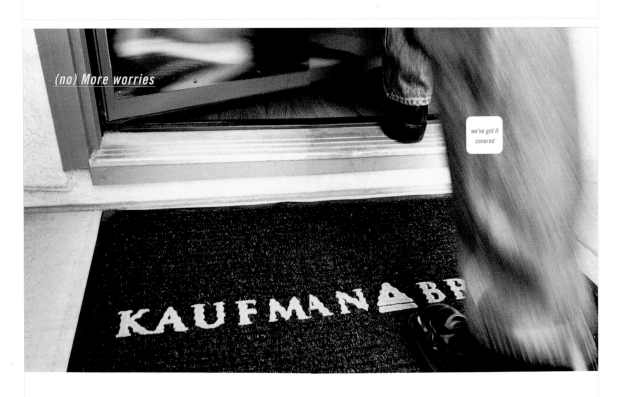

(no) More worries

we've got it
covered

KAUFMAN & BR

Just as the home buying process begins with us *listening to our customers*, it ends with us listening too. At the final orientation, every last detail about the home is checked and explained, and every question a customer has is answered. We then leave our buyers with the best housewarming gift of all – an unsurpassed *10-year limited warranty*.

THREE IS A

structurally strong number in many forms of design (just think of the Pyramids). In several spreads from the 1999 Kaufman & Broad annual report, three typographic elements (headline, computer key and text) form a visual triangle within each layout. In the financial section of the report, there are three graphs per spread. The strength of these simple, asymmetrically balanced layouts aids communication by keeping the viewer's eye on the page.

➤ DESIGN FIRM:
 LOUEY/RUBINO
 DESIGN GROUP INC.
➤ DESIGNERS:
 ROBERT LOUEY,
 ALEX CHAO

The Elements of a Clear Hierarchy

If the strategies crucial to a successful design hierarchy share a common thread, it is the intentional difference between the elements of a layout. This distinction is what invites, and then guides, a viewer through a design in order of decreasing importance.

When visual elements create a solid hierarchy—but still work together—it's most likely that one or more of the following design strategies is in use.

[1] VISUAL CONTRAST: The principles that provide visual contrast are size, value, weight, white space, position, figure/ground, texture and color. Contrast is the juxtaposition of elements; the differences create visual interest.

[2] SYMMETRICAL & ASYMMETRICAL BALANCE: Think of two children on a seesaw; if both are relatively the same size, then they can position themselves in a symmetrically balanced arrangement. But if the children are different sizes, the heavier of the two will have to move toward the center of the seesaw in

order to play. This is an example of asymmetrical balance, and it is not only a solution on the playground, but a useful design tool as well! Symmetrical layouts achieve balance through mirrored arrangements and are often the choice when a calm graphic presence is desired. Asymmetrical layouts, on the other hand, achieve balance through a less predictable, more dynamic layout. With asymmetry, the relationships of weight, size and white space work to create a "resolved unevenness."

58

kick-off party
saturday, may 3, 8:00 pm
at the dance complex
536 massachusetts avenue
central square, cambridge
it's free

for more info call (617) 547-9363

may

a month-long celebration of dance in **cambridge**

dance month

sponsored by the dance complex, the city of cambridge, and the massachusetts cultural council

dance month

kick-off party
saturday, may 2, 8:00 pm
at the dance complex
536 massachusetts avenue
central square, cambridge
it's free

may 98

a month-long celebration of dance in **cambridge**

sponsored by the dance complex, the city of cambridge, the massachusetts cultural council, and the cambridge chronicle

for more info call (617) 547-9363

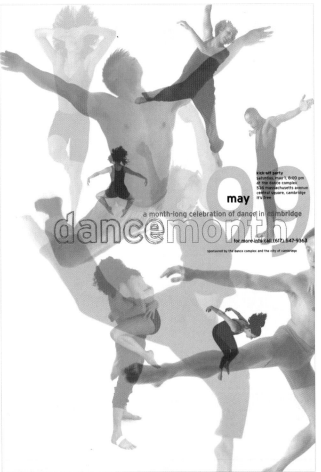

kick-off party
saturday, may 1, 8:00 pm
at the dance complex
536 massachusetts avenue
central square, cambridge
it's free

may

a month-long celebration of dance in cambridge

dance month

for more info call (617) 547-9363

sponsored by the dance complex and the city of cambridge

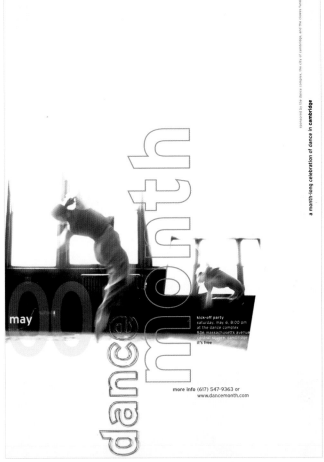

dance month

may

kick-off party
saturday, may 6, 8:00 pm
at the dance complex
536 massachusetts avenue
central square, cambridge
it's free

more info (617) 547-9363 or
www.dancemonth.com

sponsored by the dance complex, the city of cambridge, and the cloward funds, inc.

a month-long celebration of dance in **cambridge**

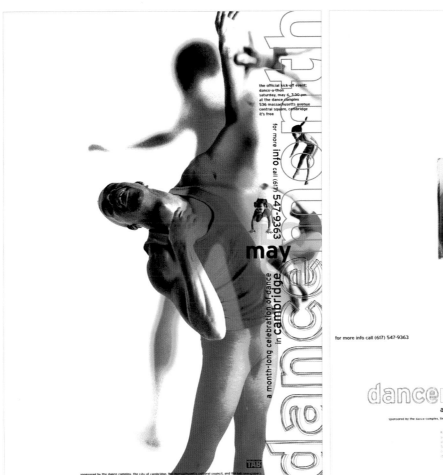

THE FACT THAT these "Dance Month" posters were done over the course of six years (one for each celebration in May) indicates two things: 1) the designer has a long-term, mutually fulfilling relationship with the client, and 2) the designer has an excellent sense of formal language. Both are admirable.

Although each poster is done a year apart, the designer has realized the value of a consistent visual presence. Throughout the series, the type is almost identically set, changing only size and position to complement the energy and movement of the photographic imagery. Each year the back of the poster features the same event calendar grid augmented with black-and-white photography from the same photo shoot as the front. Even with this rigorous formal approach, each poster feels fresh and spontaneous. Viewers might see this poster each year and feel as if an old friend has come to visit, but with all new and exciting stories to tell.

➤ DESIGN FIRM: VISUAL DIALOGUE
➤ DESIGN: FRITZ KLAETKE, IAN VARRASSI (FOR 2000 CALENDAR)

A Good Layout Guides the Viewer

In the movie *The Wizard of Oz*, the Scarecrow points in all sorts of directions when Dorothy ponders the way to the Emerald City. While that confusion is fine for a brainless scarecrow, it is a bad idea for a layout! A layout should provide specific direction to the viewer. A successful layout is very clear about what information is most important and the order in which the viewer should access all the information within the design. This is called the information hierarchy.

Even in contemporary works that seem to favor visual chaos, successful designs utilize a hierarchy within the layout that allows the viewer to make sense of the message being communicated.

neville
BRODY
The Graphic Language of Neville Brody

nk

Wh
the
sup
sor

lay-OUT

A design's layout is a map for the viewer. Think about it this way: Isn't it best to be

in a car with a confident driver who knows her destination? Those viewing a design

need to feel as if the designer knows the road—and layout is the map that makes

that possible!

.04

CHAPTER

ERASURE IN MY
CE CLARKE and ANDY BELL

COLOR AND IMAGE cropping are two essential elements in the success of this movie poster. Both take advantage of repetition to create effective visual tension. The cyan blue of the title type references the eyes of the woman in the main image. That image is repeated as highly cropped and abstracted facial images within the rows of smaller images. All of these inter-relationships provide a dynamic rhythm to the poster's layout.

> DESIGN FIRM: GLOBAL DOGHOUSE, INC.

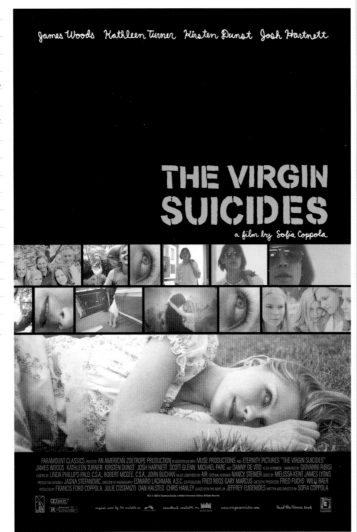

Go Wild! (Within Reason)

I have sometimes used this joke to make a point about design or a concept that has been pushed too far:

Question: How many absurdists does it take to screw in a lightbulb?

Answer: A fish.

Your attempts to create strong contrast should not go so far as to become visually absurd. Contrast can, and should, be achieved within related or logically collected palettes of type, graphic elements, images and color.

QUESTIONS WORTH ASKING

How Can You Successfully Reproduce Color?

Working with color represents a creative challenge for any designer. Successfully reproducing that color through printing and/or fabrication adds a technical challenge to the design process. Colors on the computer screen, which are projected light, rarely match the color output from your printer, which is reflected light. To further complicate the issue, each printer is calibrated differently, rendering color in its own unique way! Two possible strategies for helping insure that the final printed piece reflects your design intent are:

[1] Speak with a printer early in the design process about your plans. Perhaps the printer can suggest some solutions that can be budgeted in from the start (such as a double-black or a PMS match color) so that the final product matches what you have created on an ink-jet or laser printer.

[2] When handing the job over to the printer, always supply a mock-up of what you expect the finished piece to look like. This will give the printer the chance to work with your computer files to match your desired color outcome.

SCORE ONE FOR globalism. This "western" cantina poster advertises a large, three-story restaurant in Tokyo! The use of Tex-Mex motifs and typefaces is organized along traditional modernist principles, creating a poster that is at once both ethnic and international. The rust/olive color scheme—a low-chroma interpretation of the colors of the Mexican flag—is an excellent example of how color and identity are often associated.

➣ DESIGN FIRM: VRONTIKIS DESIGN OFFICE
➣ CREATIVE DIRECTOR/DESIGNER: PETRULA VRONTIKIS

51

THESE GIFT BAGS for the Getty Museum demonstrate the value of a carefully planned color palette. While each bag is a different hue, they share the same relative value and chroma. Choosing to vary a palette along only one color axis can be a successful strategy when the goal is to relate a series of objects.

▶ DESIGN FIRM:
KIM BAER DESIGN
ASSOCIATES

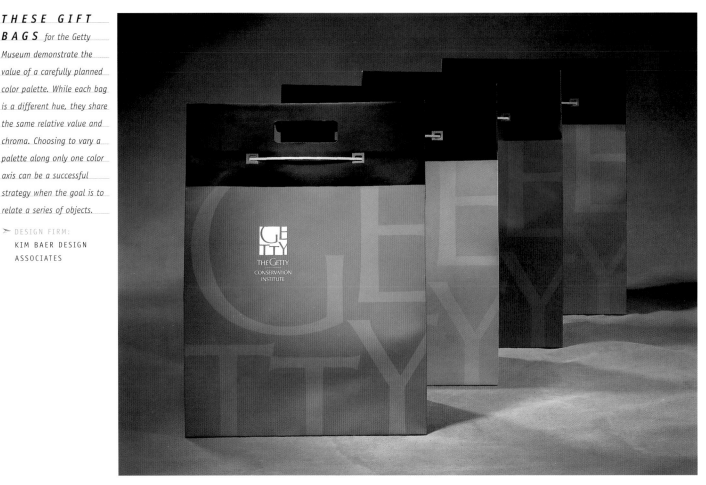

▶▶▶ CHROMA: One way to define chroma is to think of it as the "purity" or brightness of a color. Any hue can be altered along the chroma axis to make it brighter or more subtle. Chroma should not be confused with value. For instance, a high-chroma bright blue can become a low-chroma gray-blue without getting any lighter or darker—or changing to a different hue of blue.

The color combinations at left show how two fairly common colors, red and green, can be varied through value, chroma and hue to create very different impressions. The combinations vary not only from a technical standpoint, but also bring to mind different cultural associations. While one combination might be associated with Christmas, another feels appropriate for a baby's nursery. Working with color is an opportunity to add both visual interest and useful information to a design.

Contrast via Color

Color is another fairly complex tool that allows the designer to create contrast within a design. While the eye is the best judge of whether color decisions are successful, it is useful to have a shared way of speaking about color when communicating with printers, fellow designers and clients.

The terms hue, value and chroma were used by Albert Henry Munsell, an American artist, to identify the three qualities that work together to describe almost any color and how those colors may be adjusted to work better within a design.

▶▶▶ H U E : Hue refers to the distinctive characteristics of each and every color.

Think of a color wheel or the spectrum of the rainbow. Within those examples, each color (red, orange, red-orange, etc.) is a different hue.

▶▶▶ V A L U E : All colors, or hues, exist along the range of white to black. One example would be light green vs. dark green. The lightness or darkness of any color is its value.

THE RED/GREEN
COMBINATIONS
displayed show the terms value, chroma and hue in action. In the lower left, the 'basic' red and green are pure hue, high chroma and middle value. Moving counter-clockwise, the pastel tones are lighter values of the same hues. The upper right shows variations on the red and green hues (the red is more blue, and the green is more yellow), but with the same high chroma and middle value as the first pair. Finally, the deep red/green combination shows dark values and lowered chroma.

Contrast and Value

In addition to achieving contrast through order, there is also the opportunity to create contrast through value, or the relative lightness and darkness of elements on the page. Elements with the strongest value contrast (black and white are the extremes of contrast—shades of gray fall all along the range of contrast between black and white) will become more dominant on the page than elements with lesser value contrast (see triangles at left). Armed with this knowledge, a designer can utilize value to lend visual dominance to certain elements, which then works to create a useful informational hierarchy within a design.

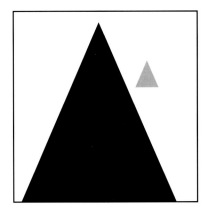 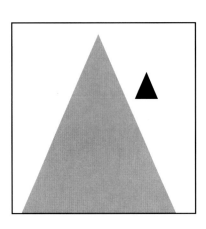

ALTHOUGH THESE COMPOSITIONS are identical, the hierarchy of each is changed through value. In the diagram on the left, the large triangle is dominant. On the right, the smaller triangle achieves dominance, despite its size, because it is the high-contrast element on the page.

THE MERGING OF photographic imagery with flat design elements is an interesting aspect of these package designs. The value shift in the background not only creates a lively pattern across multiple boxes, but it also works with the lamp photograph to "illuminate" the purpose of the product.

➤ DESIGN FIRM:
DESIGN GUYS, INC.
➤ CREATIVE DIRECTOR:
STEVE SIKORA
➤ DESIGNER:
AMY KIRKPATRICK

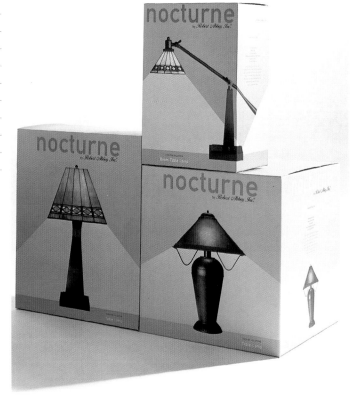

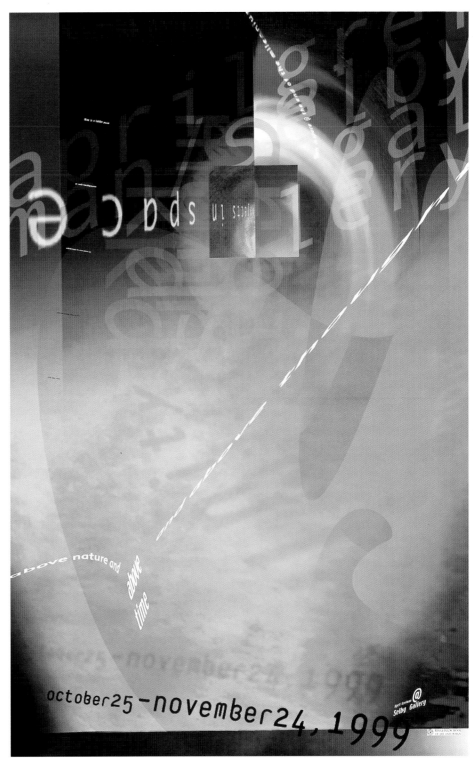

THE SWIRL AND whirl of the imagery and distorted type sets up a fiery, dreamy vortex as the first read in this poster's information hierarchy. But as soon as the viewer desires to find out what the image is about, the high-contrast information at the bottom of the poster pushes forward. Unlike some of those who have tried to imitate her work, April Greiman's explorations at the boundaries of design are continually faithful to a designer's ultimate responsibility to the message. Greiman has always been at the cutting edge of design, beginning in the late 1970s during the new wave movement. With the introduction of the Macintosh in 1984, Greiman immediately incorporated digital tools into her studio practice—a process of investigation that continues to this day.

➤ DESIGNER: APRIL GREIMAN, GREIMANSKI LABS

CONTRAST IS SUCCESSFULLY *at work in this poster series. The large scale of the flower face vs. the small scale of the type creates a clear information hierarchy. The use of the near-complementary hues within each poster allows the image to stand away from the background, adding to the attractive simplicity of the designs.*

➤ DESIGN FIRM: CONCRETE DESIGN COMMUNICATIONS INC.
➤ DESIGNERS: DITI KATONA, JOHN PYLYPCZAK

47

Creating Order

Utilizing contrast can help the design communicate a clear and useful hierarchy. A design's hierarchy is the order in which the viewer receives and makes sense of the information presented. Once a design catches a viewer's eye, it is crucial that the viewer navigate through the design's hier-

archy in the proper order—understanding the most important things first, the next tier of information second, and so on. Contrast, along with other layout tools discussed in chapter four, is key to the creation of a successful design hierarchy.

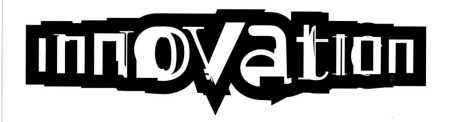

IN THIS SNOWBOARDING company logo, the complex typography is surrounded by an equally complex shape that complements, but does not directly mimic, the letterforms. This relationship is crucial for two reasons. The first is that the difference between the type and the outline creates visual tension. The second reason is cultural. If the outer shape "conformed" to the letter shapes then the whole message of snowboarding as a hip, irreverent pursuit would have been neutralized. The tension between the two elements may be visually helpful, but for the company's cultural message of tension, that contrast is essential.

➤ DESIGN FIRM: GIG DESIGN
➤ DESIGN: LARIMIE GARCIA, EDOARDO CHAVARÍN FOR GIG DESIGN

license no 541688 box 1550 oakdale california 95361 tel.fax 209.847.6308

LARRY A.GARCIA
LANDSCAPE COMPANY

45

WHILE SOME IDENTITIES

seek to show only perfect outcomes, this identity for a landscape company deals with the reality of things that grow: They are often a bit out of control! The contrast of the organic grass forms vs. the structured typography creates visual integrity and also conveys an important message: You may want some help with your lawn!

➤ DESIGN FIRM:
GIG DESIGN
➤ DESIGN:
LARIMIE GARCIA FOR
GIG DESIGN

tel.fax 209.847.6308
box 1550 oakdale california 95361

LARRY A.GARCIA
LANDSCAPE COMPANY

license no 541688

box 1550 oakdale california 95361

LARRY A.GARCIA
LANDSCAPE COMPANY

Impact
Through Form

Pushing compositions and layouts to their extreme, or at least what may seem extreme, is often the key when trying to create interesting designs via contrast. Without visual contrast, designs often fall into an uninteresting visual middle ground. The modulated use of scale, shape, texture and proportion to create contrast is a fundamental feature of successful designs.

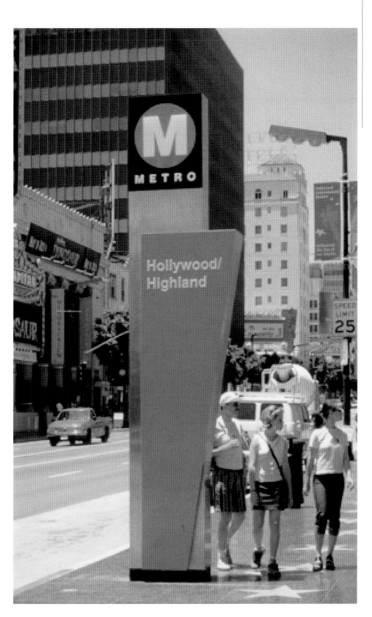

STRONG AND SIMPLE *—but dynamic—shapes allow this public transportation sign to stand out in the cacophony of the streetscape.*

➤ DESIGN FIRM: HUNT DESIGN ASSOCIATES
➤ DESIGNERS: JOHN TEMPLE, JENNIFER BRESSLER, WAYNE HUNT

[*"There is no creative aspect of graphic design more enjoyable or rewarding than the indulgence in play."*]

bradbury
THOMPSON
The Art of Graphic Design

CANTIN

con-
TRAST

Contrast doesn't just make a design visually engaging—it can also be the prime organizing factor for a design's information. Contrast can tell us where to look first in a design, what to notice second. Fortunately, contrast can be achieved in a variety of ways, limited only by your imagination.

CHAPTER .03

SPEED OF THE *boat, and perhaps of summer itself, is emphasized through the formal similarities of the image and the type treatment in the Summercamp CD cover. By creating this visual bond between the two elements, the designer has cemented two otherwise distinct elements into one cohesive message.*

➤ DESIGN FIRM: GIG DESIGN
➤ DESIGN: LARIMIE GARCIA FOR GIG DESIGN

THE SAME STRATEGY *used in the CD above is at work here, although to achieve a very different effect in the Riverwide CD cover. In this example, the title type seems to be slowly sinking into the watery background, creating a strong yet "dreamy" relationship between the elements. In this design, there is also figure–ground ambiguity (see chapter six for more about this) at work because the visible portion of the type seems to be in front of the figure, while the "invisible" portion of the type is visually related to the water behind the figure.*

➤ DESIGN FIRM: GIG DESIGN
➤ DESIGN: LARIMIE GARCIA FOR GIG DESIGN

What's right with this picture?

40

THE FIRST PAGE *of this annual report*
answers the quesiton posed on the cover. The use of different
type sizes not only emphasizes the positive aspects of the mes-
sage, but also conveys a conversational, less formal attitude.

➤ DESIGN FIRM: LOUEY/RUBINO DESIGN GROUP
➤ DESIGNER: ROBERT LOUEY
➤ PHOTOGRAPHY: STANLEY KLIMIK
➤ ILLUSTRATION: BRANT DAY

Financial Highlights

Everything.

In 1996, Kaufman and Broad made **the right moves, at the right time, in the right way.** It was also the right time to look at our business from a **completely different perspective.**

KAUFMAN AND BROAD HOME CORPORATION *1996 Annual Report*

Combining Typefaces

Using individual typefaces within the same font, such as Gill Sans and Gill Sans Italic, is a reliable way to achieve variation and emphasis within a design. Using related typefaces also helps avoid creating a chaotic effect that can result from visually conflicting letterforms. If you do want to mix typefaces from different fonts, here are a few simple guidelines to follow:

[1] Unless there is a specific reason not to, it is better to mix obviously different typefaces rather than ones that are vaguely similar. For instance, mixing Univers and Helvetica would probably just appear to be a mistake, and would bring emphasis to neither one typeface nor the other.

[2] Limit the number of variables used at one time. Consider changing either the size of the type, the weight, or the typeface—but not all three at once.

[3] Old Style typefaces tend to mix well with a subcategory of modern, san-serif faces known as Grotesque typefaces such as Franklin Gothic, Gill Sans and Optima. This is because Grotesque faces were designed combining Old Style proportions with the modern principles of simplicity. This allows typefaces from each of the groups to be very different, but to also share certain harmonious qualities.

[4] Consider all the typesetting specifications mentioned earlier in this chapter. Different typefaces within a design may require their own size and tracking in order to be visually compatible.

QUESTIONS WORTH ASKING

How Can I Manage All The Typesetting Variables?

All of the type specification decisions listed in this chapter must work in concert with the selected typeface. Typographic settings for one typeface are not automatically appropriate for another, or even the same typeface in a different size or color. Experimenting with various type specifications using sample paragraphs and headlines before one dives into the particulars of a design can help avoid frustration and in turn help any design.

QUESTIONS WORTH ASKING

Why Worry If Your Typography Is Well Set?

Can you imagine clients or customers thinking to themselves: "Well, these seem like worthwhile and interesting ideas, but the typesetting is making it hard to absorb the meaning of the text." No! Instead, readers will probably blame any lack of clarity on the content—and there goes your chance to communicate. Well-set type is a basic component of communicating clear, and therefore convincing, ideas.

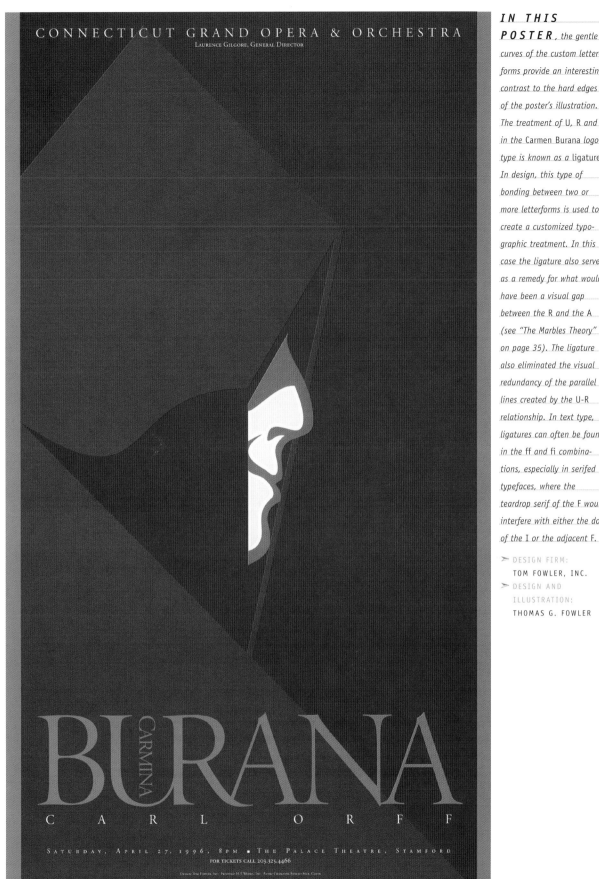

IN THIS POSTER, the gentle curves of the custom letter-forms provide an interesting contrast to the hard edges of the poster's illustration. The treatment of U, R and A in the Carmen Burana logo-type is known as a ligature. In design, this type of bonding between two or more letterforms is used to create a customized typo-graphic treatment. In this case the ligature also serves as a remedy for what would have been a visual gap between the R and the A (see "The Marbles Theory" on page 35). The ligature also eliminated the visual redundancy of the parallel lines created by the U-R relationship. In text type, ligatures can often be found in the ff and fi combina-tions, especially in serifed typefaces, where the teardrop serif of the F would interfere with either the dot of the I or the adjacent F.

➤ DESIGN FIRM:
TOM FOWLER, INC.
➤ DESIGN AND
ILLUSTRATION:
THOMAS G. FOWLER

The children and grandchildren of

A D O L P H E & S H I R L E Y
G A R C I A

request the honor of your presence

at the celebration of their

F I F T I E T H W E D D I N G A N N I V E R S A R Y

Saturday, the Twenty-Fifth of September

Nineteen Hundred and Ninety-Nine

12:00 to 4:00 in the afternoon

Lunch will be served from 1:00 to 2:30

Gladys L. Lemmons Senior Community Center

450 East A Street Oakdale, California

A GIFT TREE WILL BE AVAILABLE CASUAL ATTIRE PLEASE

THIS FIFTIETH ANNIVERSARY invitation skillfully combines several different typo-
graphic alignments: The main text (in white) is centered. The support information in black is flush left with the family
name "Garcia." Finally, at the bottom, the decorative element is centered, while the type on either side of it extends free-
form to the right and left. The result is a simultaneously casual/formal typographic attitude, perfect for such an honorable,
yet family-oriented event.

➤ DESIGN FIRM: GIG DESIGN
➤ DESIGN: LARIMIE GARCIA FOR GIG DESIGN

TYPE DANCES ON this letterhead. The use of layers, size, color, value, repetition and unexpected language (one bit of small type reads: "a purely scientific approach"!) help create a kinetic atmosphere. Interestingly, it is the use of these same design principles that keep the information clear; the office name, phone number and e-information are the dominant elements in the information hierarchy.

➣ DESIGNER: APRIL GREIMAN, GREIMANSKI LABS

▶▶▶ A L I G N M E N T S : Some projects lend themselves to certain type-alignment techniques, but don't feel like you can't take an unconventional approach (after you learn the basics listed here).

FLUSH LEFT: This is perhaps the most comfortable setting for type, as it permits the reader to begin reading each line along the same vertical axis. The rag, or uneven right side of the column, allows the letter spacing to remain constant throughout the paragraph.

FLUSH RIGHT: This setting is appropriate for small quantities of type only (such as captions) because the uneven starting point of each line adds time and effort to the reading process.

CENTERED: For the same reasons as cited with flush right type, this setting is appropriate for limited quantities of text. It is typically associated with announcements and invitations.

JUSTIFIED: The evenly aligned right and left sides of justified type make it the ideal choice for newspapers, magazines and other publications that must make the most of available space. The disadvantage of this setting is that the letter spacing is often forced into uneven patterns by the requirement that each line of text extend to the full column width.

FREE-FORM: This setting is perhaps the most contemporary of all the options and may have taken root with the efforts of twentieth-century poets such as Apollinaire and e.e. cummings. While the attention required to position each individual line of type makes free-form arrangements more labor intensive, it does offer unlimited possibilities to the designer.

The Marbles Theory

It is not difficult to space letters mathematically equidistant from one another. But to space a word so that each letter *looks* to be the same distance apart is a completely different story: Each stroke and shape of each letter prompts it to feel farther from, or closer to, each other letter. One way to help letter spacing efforts result in a visually even-spaced word is to imagine that marbles have dropped into the spaces between the letters. Then adjust the letter spacing so it appears as though the same number of marbles dropped into the space between each letter. In the example below, the type was originally too close within the *a-r-b* spaces and too far apart between the *b* and *l*. By slightly adjusting the individual spaces, the letters eventually appear to be equidistant. Additional helpful hints for custom letter spacing are to look at the type on paper (not on the computer screen), and to see the spaces in a more abstract way, either hold the paper upside down and/or squint a little bit when trying to figure out which spaces need more, or fewer, marbles.

marbles
marbles

Mitigation includes any activities that prevent an emergency, reduce the chance of an emergency happening, or lessen the damaging effects of unavoidable emergencies. Investing in preventive mitigation steps now, such as checking local building codes and ordinances about wind-resistant designs and strengthening unreinforced masonry, will help reduce the impact of tornadoes in the future.

Mitigation includes any activities that prevent an emergency, reduce the chance of an emergency happening, or lessen the damaging effects of unavoidable emergencies. Investing in preventive mitigation steps now, such as checking local building codes and ordinances about wind-resistant designs and strengthening unreinforced masonry, will help reduce the impact of tornadoes in the future.

Mitigation includes any activities that prevent an emergency, reduce the chance of an emergency happening, or lessen the damaging effects of unavoidable emergencies. Investing in preventive mitigation steps now, such as check-ing local build-ing codes and ordinances about wind-resistant designs and strengthening unreinforced masonry, will help reduce the impact of tornadoes in the future.

WHICH OF THESE blocks of text is easier to read? You'll probably agree that each block becomes progressively easier, with the bottom block being the most comfortable on your eyes and mind. Remember that the optimum line length is only about 39 to 45 characters—don't strain your reader.

▶▶ T R A C K I N G : Although the computer will, by default, determine the space between letters within a word, the skilled designer customizes that decision each time a typeface is designated for either body or headline copy. This specification is known as *tracking*, and it can refer to the overall adding (*letter spacing*) or subtracting (*kerning*) of minute amounts of space between each and every letter.

Tracking body copy typically calls for one specification to be applied to all the alike type within the entire text. When tracking type that will serve as the foundation for logotypes, headlines or words destined for large application such as signage, each word must be dealt with on a customized, letter-by-letter, space-by-space basis.

▶▶ L I N E L E N G T H : The eyes and brain can only hold to a single line of type for so long before they fatigue and drop down through the text, disrupting the reading process. The optimum line length is said to be about an alphabet and a half, or 39 to 45 letters. But, as with all the type specifications explained here, it is really the combination of multiple decisions that creates well-set type.

yarn (too close)

yarn (normal tracking)

y a r n (too spread out)

IF THE LETTER SPACING is too tight, readability is compromised. Here, the word "yarn" becomes "yam"! When the letter spacing is too loose, the word-picture falls apart, forcing the reader to stop and mentally regroup.

9/9 (nine point type with no extra leading)
Mitigation includes any activities that prevent an emergency, reduce the chance of an emergency happening, or lessen the damaging effects of unavoidable emergencies. Investing in preventive mitigation steps now, such as checking local building codes and ordinances about wind-resistant designs and strengthening unreinforced masonry, will help reduce the impact of tornadoes in the future. For more information on mitigation, contact your local emergency management office.

9/11 (nine point type with 2 points of leading)
Mitigation includes any activities that prevent an emergency, reduce the chance of an emergency happening, or lessen the damaging effects of unavoidable emergencies. Investing in preventive mitigation steps now, such as checking local building codes and ordinances about wind-resistant designs and strengthening unreinforced masonry, will help reduce the impact of tornadoes in the future. For more information on mitigation, contact your local emergency management office.

9/13 (nine point type with 4 points of leading)
Mitigation includes any activities that prevent an emergency, reduce the chance of an emergency happening, or lessen the damaging effects of unavoidable emergencies. Investing in preventive mitigation steps now, such as checking local building codes and ordinances about wind-resistant designs and strengthening unreinforced masonry, will help reduce the impact of tornadoes in the future. For more information on mitigation, contact your local emergency management office.

11/9 (eleven point type with -2 points leading)
Mitigation includes any activities that prevent an emergency, reduce the chance of an emergency happening, or lessen the damaging effects of unavoidable emergencies. Investing in preventive mitigation steps now, such as checking local building codes and ordinances about wind-resistant designs and strengthening unreinforced masonry, will help reduce the impact of tornadoes in the future. For more

11/11 (eleven point type with no extra leading)
Mitigation includes any activities that prevent an emergency, reduce the chance of an emergency happening, or lessen the damaging effects of unavoidable emergencies. Investing in preventive mitigation steps now, such as checking local building codes and ordinances about wind-resistant designs and strengthening unreinforced

11/13 (eleven point type with 2 points of leading)
Mitigation includes any activities that prevent an emergency, reduce the chance of an emergency happening, or lessen the damaging effects of unavoidable emergencies. Investing in preventive mitigation steps now, such as checking local building codes and ordinances about wind-resistant designs and strengthening unreinforced masonry, will help reduce the impact of tornadoes in the future. For more

NOTE HOW INCREASED leading can be more important to readability than type size. Lines that are too close together can create visual chaos, especially where ascenders and descenders from adjacent lines "hook" into each other.

affect the successful generation of type all work in concert to create beautiful and easy-to-read, desirable type.

▶▶▶ POINT SIZE & X-HEIGHT: The size of type is referred to in *points*. Each point (pt.) equals $\frac{1}{72}$ of an inch (although this is not necessary to memorize!). The point size of any typeface is measured from the top of the ascender to the bottom of the descender (see example below). Between the top and bottom of any typeface is the

area referred to as the *x-height*. Certain typefaces, especially modern faces purposefully designed for enhanced readability, have a greater proportion of their overall dimension dedicated to the x-height, because that is where the majority of reading perception takes place. So while one can say generally that 6 pt. type is smaller and harder to read than 12 pt. type, what matters when specifying type for legibility is not only the size, but also the design of the typeface.

▶▶▶ LEADING: Another major consideration in type specification is *leading*, the space between lines. The term "leading" dates back to the days when type was cast in metal and strips of lead were milled and used to add space between lines of type. Although the use of metal type today is limited to a few specialists, the term remains unchanged.

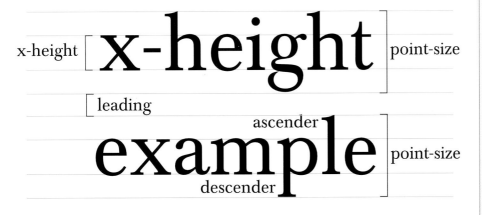

visual compatibility

THE X-HEIGHT IS *so crucial to the appearance of the type that when combining two typefaces in the same paragraph, such as Garamond and Frutiger Bold, the designer may well choose to set the Garamond larger just to achieve visual compatibility. In this example the Frutiger is 20 percent smaller than the Garamond.*

believing

The Interface brands give us a breadth of solutions that just aren't available from other companies. The product quality is better. The service is great. It all adds up when you're working on a limited budget.

KIM DALTON
Interior Designer, The Stein-Cox Group

seeing

We have specified Interface products for
all of our 350 facilities worldwide.
The qualitative advantages of the product are obvious. But it also means a great deal to us that Interface has a strong environmental conscience and has found ways to make a better product in a better way.

ROSE TOURJÉ
Director of Design, Warner Bros. Corp. Real Estate

THESE SPREADS FROM an annual report integrate classic typeface choices with unexpected typographic scale change. The juxtaposition of the Old Style type with a contemporary illustrative style adds to the visual appeal of the designs. Note how the centered typography on the pages is complemented by the limited use of flush right and flush left typographic elements.

➤ DESIGN FIRM: VSA PARTNERS, INC.

jump!

believing

one world learning helps organizations learn how to achieve sustainable business performance. We don't practice reengineering. And we don't offer prepackaged recipes for success. We simply help companies and the people within them create meaning and define a greater purpose for themselves. Then, we help connect that purpose with performance. We're really just sharing with others the same thinking that has made Interface so successful. The result can be a truly empowered organization. But it won't happen without courageous leadership from the top down. Looking at it in terms of a one world ropes exercise, the CEO has to jump off the pole before everyone else does.

DAVID BLACK
President, one world learning

seeing

(before Kim's first one world learning session)
I hope this lives up to expectations. Honestly, I'm a little skeptical.

(three months later)
The people in our company who have been through one world learning have a much better understanding of how they can help our company be more successful as we progress on our journey to improve the culture at PGA. It was a powerful catalyst for change for our people, not just as employees, but as parents, partners and professionals.

KIM JEFFERY
President, Perrier Group of America

believing

Some of the most intriguing people in history – Chief Joseph, Susan B. Anthony, and Winston Churchill are a few examples – were living comfortable, quiet lives when, through crisis or epiphany, they were suddenly transformed into true leaders. They reinvented themselves and became heroes, representing for all of us what is best about humanity. Companies can do the same thing. I think Interface is an example of that.

WILLIAM BROWNING
Director of Rocky Mountain Institute's Green Development Services
National Real Estate Advisor to The Nature Conservancy
Board Member, U.S. Green Building Council and Greening of America

seeing

"New ideas,
both large and small,
are fostered
here like no place
on Earth."

U.S. News & World Report, December 28, 1998/January 4, 1999
From "American Innovators," an article celebrating 18 business and civic leaders who have made innovation a force in American culture. Interface CEO Ray Anderson was among those profiled.

THE STRUCTURAL ESSENCE *of the Bodoni typeface pro-vides a visual counterpoint to the organic forms of the figure. The playful arrangement of the letterforms softens that structural essence a bit, helping integrate the entire identity without sacrificing the visual strength of each element.*

➤ DESIGN FIRM: GIG DESIGN
➤ ART DIRECTION AND DESIGN: LARIMIE GARCIA FOR GIG DESIGN

THE TYPOGRAPHIC PERSONALITY *of the heavy slab-serif typeface sets the proper tone for this Austin Gym logotype. The strong proportions and thick strokes of the A are reflected in the stylized forms of the figure. The two components of the logotype are so visually intertwined that the serifs at the bottom of the A also serve as the weightlifter's hands. The fine white lines within the thick strokes add contrast as well as visual information that helps the bottom part of the identity read as a figure.*

➤ DESIGN FIRM: RBMM
RBMM DEVELOPED THIS PROPOSED CORPORATE MARK

Typeface
Technology & Terms

With the various desktop design programs permitting typeface specification and manipulation without any formal design training, the vocabulary and technical knowledge once essential to type handling is now often overlooked. Unfortunately, so are some of the most basic practices that once guaranteed clean, sophisticated and well-set type. Informed, skillful type handling separates well-designed type from the efforts of the average designer. That undefinable level of finish in the best designs is often a result of type handling that reflects not the latest trend or typographic fad, but the employment of traditional type practices. The following terms and explanations of how they

Typographic Personality

Imagine that there were only three typefaces in the world (Bodoni, Goudy and Democratica), and your clients were an organic market, a law firm and a Goth band. Which typeface personalities would align with each of the applications? Just as with human beings, the personality of a typeface will come through no matter what. It is a gift to the designer to be able to take advantage of the message(s) that a typeface's personality offers regarding the communication of the message.

For instance, Goudy was designed in 1915 during the Arts and Crafts movement, which favored stylized organic, plantlike forms in its designs as an attempt to fend off the influences of the industrial age. Bodoni (1818), by contrast, embraced the rigors of industrialization, which is reflected in its clean, precise forms and its squared-off serifs. And finally, there is Democratica, whose visual idiosyncrasies reflect Gothic-era forms although it was designed in the late twentieth century.

While many other typefaces would also be appropriate starting points for these graphic identity projects, a designer should always consider, and take advantage of, the message a typeface naturally communicates.

Benita's Organic Haven
Fenton, Fenton & Partners
Dead prophet

QUESTIONS WORTH ASKING

How Can I Learn About New and Interesting Typefaces?

You can find showings of many, many typefaces through the print and online catalogs of companies that sell type. Three type houses that you may want to investigate are: Adobe <adobe.com/type/main.html>, Emigre <emigre.com> and ITC (International Typeface Corporation) <itcfonts.com>. Adobe and ITC carry the classic typefaces as well as the new and unusual. Emigre is the acknowledged pioneer in new type design and carries fonts by such type-design notables as Ed Fella, P. Scott Makela and Zuzana Licko. As part of their marketing efforts, Emigre and ITC also publish interesting magazines about typography and graphic design that feature their respective typeface offerings.

QUESTIONS WORTH ASKING

What Is a Typeface? What Is a Font?

A font is a family of typefaces all derived from the same basic type design. The Bodoni font includes Bodoni, Bodoni Italic, Bodoni Bold, etc. Some fonts, such as Univers, feature over twenty typefaces, ranging from Univers Condensed Light to Univers Ultra Bold Extended. Within any given font, each specific variation is a typeface.

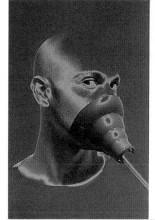

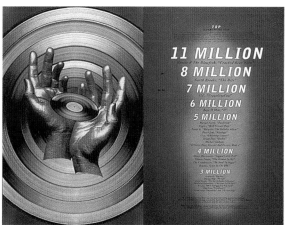

ROCK
COUNTRY
URBAN
POP
RAP
GOSPEL
JAZZ
CLASSICAL
SOUNDTRACKS
CHILDREN'S

THIRTY
FIVE
39

11 MILLION
8 MILLION
7 MILLION
6 MILLION
5 MILLION

4 MILLION

3 MILLION

INNOVATIVE TYPOGRAPHIC TREATMENT is used throughout this annual report. For example, the words "rewind" and "fast for- ward" (on the second panel) are designed to act out the actions to which they refer. The canted and reversed directions of the letterforms successfully reference the whackiness of hearing a recording at the wrong speed. Juxtaposed with the imagery, the typography makes this a strong package.

➤ FIRM:
RECORDING INDUSTRY
ASSOCIATION OF
AMERICA
➤ CREATIVE
DIRECTOR/DESIGNER:
NEAL ASHBY

THE VALUE CHANGE between the black-and-white letter- forms creates a visual bounce in the title type on the Happiness CD. The various packages are all for a twelve-set collection in which each CD explores a particular musical theme. The upbeat mood of the Happiness CD is clearly conveyed through the typographic flowers, bright colors, scale changes and lively type treatment.

➤ DESIGN FIRM:
CLIFFORD STOLTZE
DESIGN
➤ ART DIRECTOR:
CLIFFORD STOLTZE
➤ DESIGNERS:
TAMMY DOTSON,
CLIFFORD STOLTZE
➤ CLIENT:
HAYHOUSE FOR
WINDHAM HILL

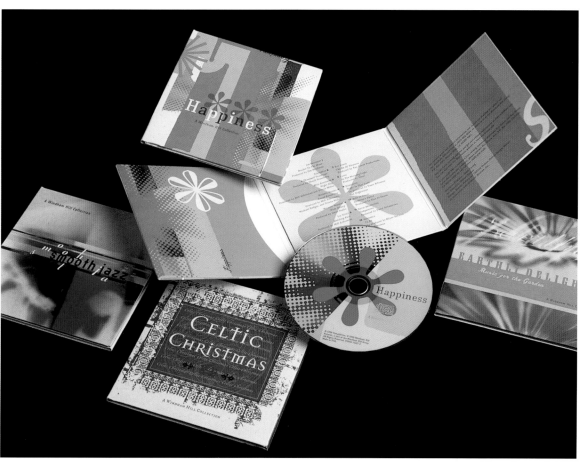

FIG. 2.2　　　　OLD STYLE

Garamond
Caslon 540
Bembo

FIG. 2.3　　　　TRANSITIONAL

Baskerville
Bodoni

FIG. 2.4　　　　MODERN

Gill Sans
Futura
Univers 55
Frutiger

FIG. 2.5　　　　DIGITAL

Matrix
Out West
Mrs. Eaves
crash

toward clean, minimal statements. In keeping with the *Moderne* movement, type design was simplified with the elimination of serifs, the use of visually even strokes and an emphasis on a lean, machined look for the type (see figure 2.4).

▶▶▶DIGITAL: The advent of the desktop computer and programs such as Fontogapher have allowed for all sorts of typographic experimentation (see figure 2.5). Some contemporary faces, such as Mrs. Eaves, pay homage to an Old Style aesthetic. (It's rumored that the actual Mrs. Eaves was the mistress of type designer, John Baskerville. Whether or not that's true, the typeface named after her is definitely influenced by the typeface that bears his name.) Others are attempts to capture a specific, more contemporary, cultural attitude. Crash, for instance, conveys the dispirited attitude associated with grunge music, a stalled economy and Generation X.

Type History

As with almost any other arts category, typographic design has followed historic trends and technology. For present-day designers, a basic understanding of typographic history—from the chisel to the pixel—can help when making appropriate, sophisticated and even unique contemporary typographic decisions.

Most people already know a bit about type history just by intuition and can differentiate an "old-fashioned" typeface from a contemporary

FIG. 2.1

typography

typography

WHICH TYPEFACE IS "OLDER"? Even though both are used in the present day (Martha Stewart Living magazine regularly features both), these typefaces still reflect the aesthetics of the times in which they were designed. Garamond dates back to the 1500s, while Gill Sans is a machine-age typeface designed in 1927.

one. That is because the design of a typeface often exudes the characteristics of the time it was designed (see figure 2.1).

Type Design

A fundamental aspect of type history is the chronological typographic categories: Old Style, transitional, modern and digital. The first three are often identifiable visually; the fourth is the wild-card category. The explosion of digitally generated typefaces has fostered an experimental attitude regarding the generation of new alphabet designs. While there are exceptions to all of the categories, some basic characteristics of each are as follows.

▶▶▶OLD STYLE: Typefaces in this category are serifed and reflect the calligraphic heritage of letterform design. Note the angled axis in the letters, a vestige of the chisel point tools used since ancient times to carve, draw and paint letters (see figure 2.2).

▶▶▶TRANSITIONAL: While most transitional typefaces are serifed, the contrast between the thick and thin strokes within the letter is less extreme than in Old Style faces. Also, the axis of the letter as well as the serifs have straightened out, leaving the legacy of calligraphy behind and giving the letterforms a cleaner, more manufactured look (see figure 2.3).

▶▶▶MODERN: By this era in type design (and all forms of design in general), the trend was

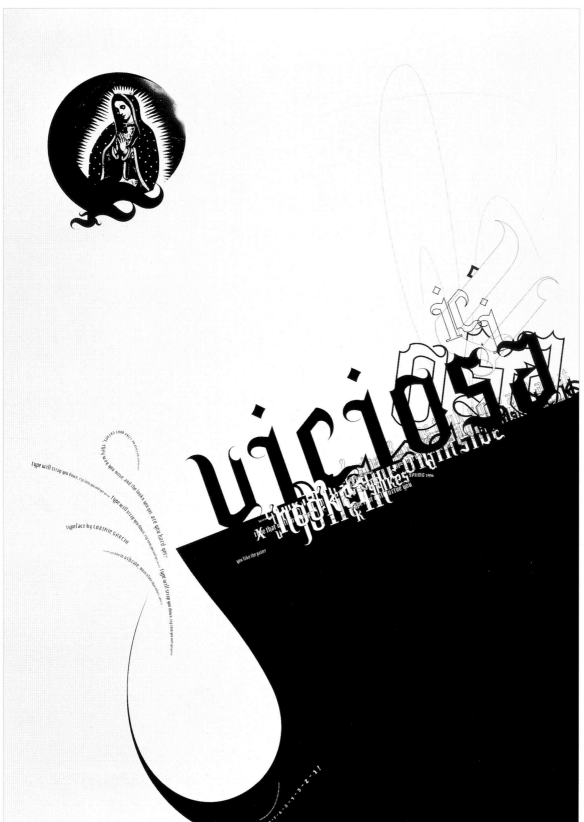

IN THIS
DISPLAY of the
typeface Viciosa, the
"organically Gothic" charac-
teristics of the letterforms
are reflected in the overall
design of the poster. Notice
how the lines of text and
the background shape suc-
cessfully mimic the formal
language of the type design.

➤ DESIGN FIRM:
 GIG DESIGN
➤ TYPEFACE AND POSTER
 DESIGNED BY:
 LARIMIE GARCIA

The Art of Typography

The artful representation of words—typography—is a fundamental building block of graphic design. In many ways typography and the use of written language is what separates graphic design from other design pursuits such as fashion, architecture and product design.

Back in the days of hot-metal type, skilled artisans devoted themselves entirely to the craft of typography. Now, as the egalitarian optimism of desktop publishing—which put the tools of typography into everyone's hands—is fading, it is important to remember that typography is an art, and cannot be left solely to the computer to accomplish. True typographic mastery can take many years of practice. But as with any long-term pursuit, the first steps are the most important:. A basic understanding of type history, design, technology, and vocabulary will help lay a strong foundation for successful typographic efforts by anyone willing to pay attention to the details of how he or she handles type.

IN THIS INTRODUCTORY screen for a famous toy store's Web site, the use of multiple type sizes, an uneven baseline, positive/negative letterforms and the integration of shapes into the typography all contribute to a playful interpretation of the basic logotype.

➤ DESIGN FIRM: RAZORFISH
➤ CREATIVE DIRECTOR: PETER SEIDLER

["Without words, without writing and without books there would be no history, there could be no concept of humanity."]

hermann HESSE
as quoted in Hermann Zapf's Manuale Typographicum